W9-AJS-582

BY JANET WALLACH

Looks that Work

Working Wardrobe

Desert Queen

WITH JOHN WALLACH:

Still Small Voices

Arafat: In the Eye of the Beholder

CHANEL

HER STYLE

AND

HER LIFE

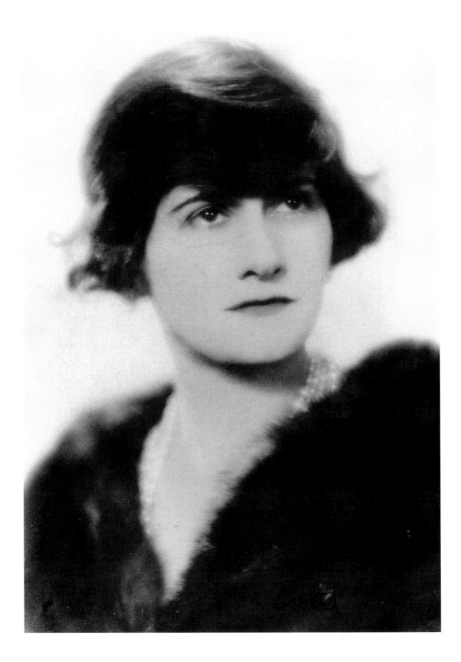

Janet Wallach

CHANEL

HER STYLE

AND

HER LIFE

NAN A. TALESE

DOUBLEDAY

New York London Toronto Sydney Auckland

FRONTISPIECE: **CHANEL WEARS TWO**
of her favorite things: furs and pearls. Her necklace
was a gift from the Grand Duke Dimitri.

PUBLISHED BY NAN A. TALESE
an imprint of Doubleday,
a division of Bantam Doubleday Dell
Publishing Group, Inc.
1540 Broadway, New York, New York 10036

DOUBLEDAY is a trademark of Doubleday, a division of
Bantam Doubleday Dell Publishing Group, Inc.

Book design by Marysarah Quinn

Library of Congress Cataloging-in-Publication Data
Wallach, Janet, 1942–
Chanel style / Janet Wallach. — 1st ed.
p. cm.
Includes bibliographical references and index.
1. Costume design—France—History—20th century.
2. Chanel, Coco, 1883–1971. I. Title.
TT507.W2158 1998
746.9'2'092—dc21
[B] 98-22665
CIP

ISBN 0-385-48872-6
Copyright © 1998 by Janet Wallach
All Rights Reserved
Printed in the United States of America
November 1998
First Edition in the United States of America

1 3 5 7 9 10 8 6 4 2

For John

Acknowledgments

Of the many people who helped with this book I would particularly like to thank the following: in New York, Arie Kopelman at Chanel; Eleanor Lambert; Ward Landrigan at Verdura; Valerie Steele and the library staff of the Special Collections of The Fashion Institute of Technology; Richard Martin, Dennita Sewell and the librarians at the Costume Institute of the Metropolitan Museum of Art; Ted Barber at the Parsons School of Design. In Paris, Marie-Louise de Clermont-Tonnere, Marika Genty, Arlette Thebault, Veronique de Pardieu and Sophie Lorthiois at Chanel; Catherine Ormen at the Musée de la Mode et du Textile; Vivian Cruise and Holly Warner. A special note of appreciation to Astrid Lewis and Karen Pesavento for their research work; to my agent, Linda Chester, and Laurie Fox; to Mario Pulice, Creative Director at Doubleday; and to Alicia Brooks and Claire Roberts at Nan A. Talese/Doubleday. This book was the vision of my editor Nan A. Talese, whose style, elegance and intelligence recall those of Chanel.

Contents

Introduction

ON AN AUTUMN EVENING in Paris in 1970 on the Rue Cambon, in the private apartment above the Chanel salon, the beige rooms glowed with a special light. Candles flickered everywhere, their light reflected in the crystal chandeliers, in the large gilt-framed mirrors on the walls, on the lacquered Chinese tables and in silver boxes bearing aristocratic stamps. Logs crackled in the fireplace, fresh flowers filled the air, and pairs of bronze deer stood on the floor like silent footmen. Two of the guests invited for the special dinner—in honor of the Duke and Duchess of Windsor—had already arrived. Diana Vreeland, former editor-in-chief of *Vogue*, and Niki de Gunzburg, her close friend and former fashion editor, sipped their drinks and chatted with their hostess. Coco Chanel, small, slim and clearly in charge, stood in the pose she had made famous: her shoulders rolled back, her hips thrust out, one foot in front of the other, one hand in her pocket, the other holding a cigarette. Her flashing eyes and broad red mouth enlivened her simian face as she talked rat-a-tat-tat, radiating energy throughout the room.

When the butler announced the guests of honor, Mademoiselle Chanel, wearing a white silk, side-buttoned suit, moved quickly toward the door. Reaching out to the Duke, she trained her dark eyes on him and welcomed him inside, excluding everyone else from her glance. Steering the former king past the Coromandel screens and into the drawing room, she sat down beside him cozily on the cocoa-colored suede sofa. Their eyes now locked, their voices low, the twosome chatted almost in murmurs, their monotone stopped only by an occasional spurt of laughter.

The spell wasn't broken until one of the other guests reminded their hostess that they had, of course, been invited to dinner. With a word to her butler, Chanel rose from the sofa and parted from the Duke. But only for a moment. At the dining table, he was seated beside her once again. Their eyes on each other, they picked up their intimate conversation as though they had never left off. The other guests watched in awe. "I have never seen such intensity in my life," Diana Vreeland said. "Obviously, they once had a great romantic hour together."

Coco Chanel was almost eighty-five years old that night when the Duke of Windsor came to dinner, yet she was still able to entrance him. With her mesmerizing energy, she had almost always been the center of attention, and she had almost never been without a man. A self-made millionaire and founder of the first fashion empire, she had captured the admiration of millions of women around the world and captivated dozens of men, among them some of the richest, most powerful, most gifted, most famous in Europe. Passionate, focused and fiercely independent, Chanel was a virtual tour de force.

To celebrate Chanel is to celebrate life in the twentieth century, and in particular the art of living as she practiced it. Whatever she did, wherever she went, whatever she said, revealed her unique style and taste. She was a successful designer, she liked to say, because she was the first to live the life of the twentieth century.

With daring disdain for the Establishment, Chanel created a magical world that still informs our sense of style. To understand her success is to understand her strengths and her goals. Born in poverty, orphaned and disciplined by denial, she longed for luxury, wealth and independence. She had a gift for fashion, which was a necessity in her time, and she used it to her advantage. She created clothes for others that were the

clothes she created for herself, and she took her designs from what she saw nearby.

Her genius lay not in the fanciful but in the functional. Her talent was her ability to adapt what was around her, whether it was the result of borrowing a boyfriend's sweater to keep warm, or admiring a sailor's cap and restyling it as her own. Anything and everything in her path became material for her fashions.

Where other designers imposed, Chanel implied. Where other designers foisted their fantasies or demanded constraints, Chanel offered liberation, firm in her conviction that women could be free.

A paradigm of the modern woman, she wanted independence and affection, success and security. Indeed, romance held an important place in her life, for Chanel believed that to be without love was to wither away. She depended upon men for sustenance, and they gave her that and more. They introduced her into society, taught her about business, and treated her to luxury. They gave her inspiration and she counted on them to give her love. Yet she cherished her work as much as she cherished men.

She is remembered, of course, for her clothes, and few designers' names are so readily connected to particular items, or so instantly conjure up images: the Chanel bag, the Chanel shoe, the Chanel suit. Yet it was above all an *attitude* that she imparted, and that women still want now, and it has made Chanel style span nearly a century.

Harsh Beginnings

LIKE AN ANGRY SCHOOLGIRL scrawling crayons across a picture, Gabrielle Chanel obliterated her childhood. She was born in Saumur in August 1883, but spent much of her time growing up in the austere land of Auvergne. She herself was as tough as the peasants who farmed there: a feisty, fiery little girl. "I am the only crater of Auvergne that is not extinct," Chanel declared at the age of seventy. Yet she had fought hard to push away the past.

She was a child of poverty and infidelity; of a frail, sickly mother, Jeanne, and a philandering father, Albert, an itinerant peddler from the south who sold his wares to housewives in the marketplaces. Albert was quick to wander to other towns and other women. Gabrielle adored her dark-haired, mustachioed father and looked forward to his infrequent visits home. Her mother's constant illnesses meant that there was little time for playfulness in the household. Gabrielle was less than twelve when her mother died of tuberculosis, and only a few weeks older when, rejected by all other family members,

her restless father abandoned her and two sisters to an orphanage at Aubazine. She never saw her father again.

In the care of the nuns of the orphanage, Gabrielle was miserable, starved for affection and too unhappy to admit it. Pride was the key to her character, and it burst through her eyes, her voice, her gestures, her actions. She was lonely and angry, and she rebelled against all. "I was a child in revolt," she confessed. But she clung to the image of her father: handsome, adventurous, a man who spoke English and loved to travel. He was the first to call her "Coco," she later told friends.

Given the choice of becoming a nun or continuing school, Chanel refused to join the novitiate. Instead, at the age of eighteen, she was sent as a charity case to Notre Dame, a convent boarding school in Moulins. This ancient town, with its gothic cathedral and campanile, was a far more attractive place than the orphanage. But life at the school was harsh. Discipline was strict and the differences between the rich and the poor were put sharply in focus: forced to stay apart from the paying students, she and the other indigent girls lived in unheated quarters, sat separately in class, ate inferior food and dressed in plainer, rougher clothing. Humiliated by the poverty, she was intensely conscious of the way people lived and keenly aware of the way people looked.

She noticed the soft fabrics of the other girls' outfits, the big white collars and floppy ties of the neighboring schoolboys, the black gowns and starched white wimples of the nuns. The spare rooms, the stained glass windows, the bold crosses and crucifixes all made a deep impression on her.

She learned to sew at the boarding school, and her first job was that of a shopgirl for A Sainte-Marie, a lingerie and trousseau firm in Moulins. Soon she took on a second job working extra hours for a tailor, mending the uniforms of the army officers stationed in the garrison town.

In the little spare time she had, she visited her father's family, who lived nearby. She was eager for love and acceptance, yet bitter at having been abandoned, and she felt both rage and affection when she called on them. With her father's sister Julia, and his youngest sister Adrienne, who was close to her in age, she practiced her skills at sewing. She learned to ride, straddling their horses bareback, soaring across the fields.

Her relatives' homes, however, were as much places of anguish as

escape. Again and again in various versions she recalled to friends her first visit to the house of an aunt, where she arrived starved for affection as well as for food. The hour was late, her stomach empty, when she was greeted circumspectly and offered a meager supper of boiled eggs. The young Gabrielle refused to eat, saying that she detested eggs. The truth was, they were one of her favorite foods. But she was too hurt to show her need and accept the offer. At future meals, she would be forced to watch as omelettes, soufflés and puddings passed under her nose, but the orphaned girl would never allow her weakness to be exposed.

Somewhere in an aunt's attic she found another kind of nourishment. Hidden away in the dark, she discovered newspaper serials of popular novels, and one after another, she devoured the romantic stories whose fictional heroes and heroines shaped the young Chanel's hopes and dreams. Given the spare food at her aunts' and in the convent, the novels' five o'clock rendezvous made her yearn for lavish afternoon teas in the English style, with cakes and sandwiches and scones. Forced to wear black for so many years at the orphanage and at school, the fabulous wardrobes in the books whetted her appetite for vibrant clothes.

Inspired by one of the chapters, she designed a brightly colored dress for her graduation. On the day of the big event, she donned layers of clinging mauve crepe de chine and stepped carefully into flounces of purple velvet. Then, playing the sophisticate, with her tiny frame swallowed up in the garish style, she proudly descended the stairs and came face-to-face with her aunt. The look of shock in her relative's eyes was matched only by Gabrielle's embarrassment and shame. But the lesson was not lost; clean lines and subtle colors became hallmarks of her design.

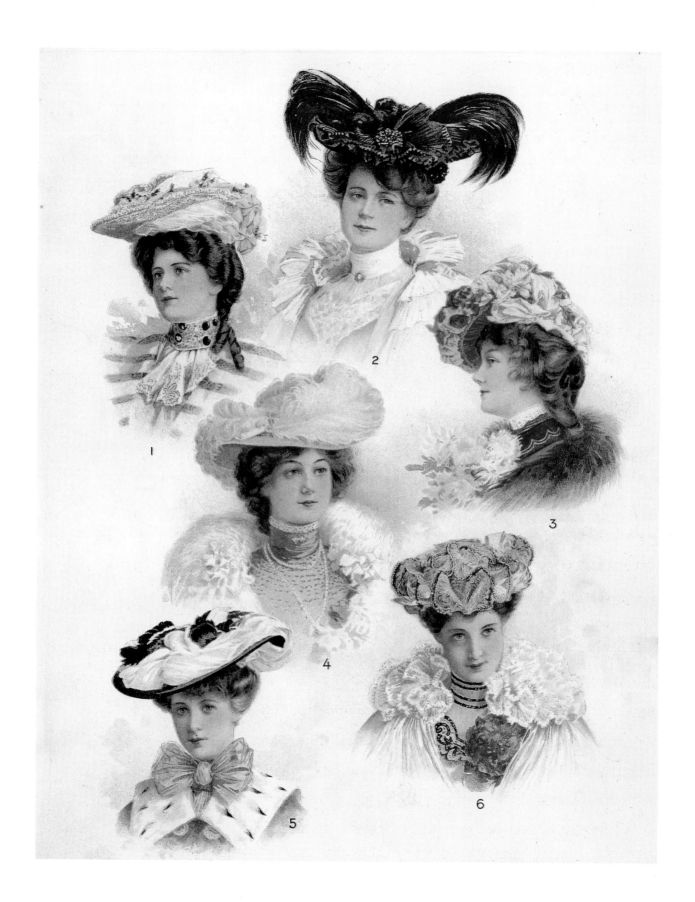

A Heady Start with an Heir

AFTER A CHILDHOOD scarred by poverty, Chanel set out to heal herself through wealth, but not through marriage. For her, money equaled independence. Dreams of fortune and even adoration filled her monotonous days toiling in the shops; in the evenings she performed in a popular Moulins cabaret. The soldiers stationed in town, some of them young aristocrats, often came to the café-concerts, as the clubs were called, to hear a song, have a beer and admire the flesh. They were not charged for the entertainment; the girls were paid by going from table to table, passing a hat.

With her dark hair, flashing eyes and gamine form, Gabrielle stood on the stage and sang out the words to the only two songs she knew: "Ko Ko Ri Ko" (Cock-a-doodle-do) from a popular music hall review; and "Qui Qu'a Vu Coco," (Who Has Seen Coco), a ditty about a lost dog named Coco. The name caught on, and the boisterous soldiers soon called out to her, "Coco! Coco!"

While she lacked the voluptuous figure of the other performers, Gabrielle possessed a generous ability to

AT THE TURN OF THE *century, fashionable hats were piled high with feathers, flowers and fruits. "How can the brain function in those things?" Chanel sniffed.*

LEFT: ÉMILIENNE D'ALENÇON,
*A girlfriend of Étienne Balsan, was
one of the most famous
demi-mondaines in France.*

RIGHT: **THE SINGER MARTHE**
*Davelli was a close friend of Chanel
and helped promote her clothes.*

flirt. She purred with her voice, batted her lashes and looked into the eyes of the young men adoringly, and it wasn't long before the young coquette was enjoying a good meal or a gift for her charms. As a singer, however, her career was doomed: despite numerous lessons, her voice was simply not good enough. Shopgirl or seamstress seemed to be the best she could do—until she met Étienne Balsan.

A cavalry officer whose family fortune came from manufacturing textiles, Balsan was rich, recently orphaned, and nearing the end of his tour of duty when he asked Chanel to join him at Royallieu. There, at his country estate in Compiègnes, not far from Paris, he bred pedigreed horses and kept pretty women. His fillies were among the fastest in the country, running at Auteuil and Longchamp; his women were among the raciest, famous figures, such as Gabrielle Dorziat the actress, and Émilienne d'Alençon, perhaps the best-known courtesan in France. The invitation was too good for Chanel to refuse. She jumped at the chance to be Balsan's cocotte. It was a vast improvement over her circumstances.

Mistress, courtesan, horizontale, irreguliere, cocotte: no matter the name, the notion to some was of a sensuous figure of whimsy and wit

who controlled the hearts and minds of powerful men; to others the role implied an object demeaned by males, an erotic toy put on earth expressly for the pleasure of men. Whether they were seen as leaders or led, romantic heroines or unrepentant harlots, courtesans were a French tradition three hundred years old. They had a status aspired to by poor girls who grew up hoping to find rich men to care for them. Their dreams went beyond the drudgery of a dull marriage and a working-class life. Like Gigi, the amusing and beautiful namesake of the novel by Colette, they learned to please a man in every possible way.

IT TOOK A GRACEFUL *woman to wear the fashions of the day. While climbing into a carriage, these ladies had to lift their skirts and hold their heads high under their huge hats.*

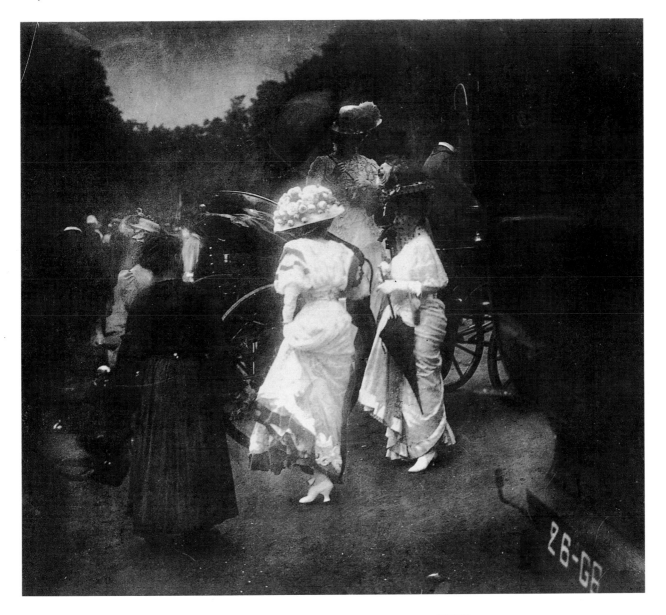

ATTENDING THE RACES, THE
*Duchess of Westminster and her
friends wear extravagant hats and
elaborate dresses.*

CHANEL CARED FOR HER
boyfriend Boy Capel more than for
any of her other lovers.

Stories of the fancy ladies spun through France like candied sugar. Parisian social life counted on the glamour of mistresses and courtesans as much as it did on the aristocracy and the bourgeoisie. If the latter two had position and wealth, the former had high style, elegant manners and smashing wit. They were the celebrities of their day, and girls like

Chanel carefully watched their ways and their wardrobes. Thumbing their noses at the middle class, the coquettes released themselves from petty social rules and indulged in a style that weary housewives dreamed of living and bored husbands dreamed of sharing.

The kept women were ensconced by their lovers in grand mansions and financed with great sums of money; they were lavished with jewels and furs and fought over in deadly duels. Their clothes were created by the finest couturiers, their homes furnished with art and antiques, their parties filled with upper-crust men; and although they sometimes served as a cover for homosexual males, more often than not they were tokens of sexual prowess.

Decked out in their finery, in the mornings the ladies showed themselves off in the Bois de Boulogne, parading in carriages or promenading on foot alongside the elite. Afternoons they viewed the art exhibits, cheered at the races or followed the matches on the polo field. Wearing their newest gowns, on Monday nights they attended the opera and on Tuesday nights the theater, and on any given evening they dined at Maxim's or the Café de la Paix, always amusing their lovers with intelligent talk and, later, an interesting bedside manner.

For Chanel, the fictional heroines of the novels she read were brought to life at Royallieu, where nobles and heirs such as Baron de Foy or Léon de Laborde or Balsan's brother Jacques (who later married the American heiress Consuelo Vanderbilt) often arrived with at least one young woman on the arm. Playfully seductive, elaborately clothed, the "demi-mondaines" (named after the title of the popular play by Dumas fils) were dressed in layers of ruffles and flourishes, their exuberant figures tightly laced and corseted under their silk and satin gowns.

With plunging necklines, tiny waists and plumped hips, they fashioned their bodies into a sensuous S shape. They turned their heads into gravity-defying wonders: hats of cartwheel shape or with turned-up brims were massed with birds of paradise feathers, sky-high plumed aigrettes, jewels, fruits or flowers. These buxom, beautiful women were in clear contrast with the flat-chested tomboy Chanel; at the beginning she was too overwhelmed to do more than observe.

And then there was the setting: the opulent house at Royallieu with its carved antique chairs covered in tapestry or leather, silver objects that sparkled on the highly polished tables, and bouquets of flowers that fragranced the rooms. The lavishness nearly took her breath away. The

THE OPERA SINGER
Gabrielle Dorziat was one of the
first theatrical stars to be shown
wearing a hat by Chanel.

stage and the players were almost too much for her to comprehend. She was in competition with the leading courtesans of the day, yet her boyish figure could hardly rival their bosomy forms, her modest means could never match their well-heeled bank accounts, and her simple manners hardly equaled the splendid surroundings. Nonetheless, she was determined not to be outdone.

Her quick tongue enabled her to keep up a clever conversation, and her ability to ride as well as any man gave her an advantage with Balsan. Her lover was nearly as mad for horses as he was for women. What's more, she could distinguish herself by dressing differently from the others. Knowing that her diminutive figure would be submerged in the excessive fashion of the day, she showed off her long neck and slim shape by making pared-down clothes for herself and even wearing

shirts, ties, jackets and jodhpurs that she borrowed from her male friends.

Best of all, the hats she created attracted a bit of attention. Instead of the heavily feathered or flowered spheres of great height and enormous width (which grew even wider as women tried to narrow the look of their hips), Chanel used smaller, less complex frames and embellished them, at most, with only a touch of blossoms or plumes.

The famous cocottes were struck by her simple approach. The actress Gabrielle Dorziat and the opera singer Marthe Davelli asked if she would do up some styles for them. When pictures appeared in the press of them wearing her hats on stage, Chanel's reputation was started. Photographs of her appeared in 1910 in the theatrical periodical *Comoedia Illustrée*. As other designers followed her styles, and the smaller hat became more fashionable, Chanel was recognized as an important hat designer. Her hats and accessories did more than top an outfit; they created a total look. But for the moment her market was limited to Royallieu.

LEFT: **CHANEL MODELS ONE** *of her own creations for* Comoedia Illustrée *in 1910.*

RIGHT: **INSTEAD OF EXCESSIVE** *ornaments, Chanel used a large plume to decorate her hat.* (Comoedia Illustrée)

Boyish Escapades

IN 1912, Chanel met Arthur "Boy" Capel, who dazzled her with his dark looks and dashing profile. "He was more than handsome, he was magnificent," she recalled, referring to his penetrating eyes, thick black hair, broad mustache, and his profile, which seemed to resemble Clark Gable. His British background was blurred, but his ability to make money and friends was clear. By the age of thirty his intelligence and shrewd sense for business had earned him a fortune in shipping and coal, while his charismatic style and talent for playing polo had put him at the top of the social list.

She saw him first at Pau, a smart town for the racing set, and turned her charms on him at once. With coquettish technique she looked longingly into his eyes, fluttered her lashes, played her necklace to her lips and slithered her body closer to his. He was soon a regular guest at Royallieu.

Like Balsan, Capel had a long list of lovers, and like Balsan, he quickly added Chanel's name to it. Indeed, for a while the two men and Chanel seemed to be a ménage à

trois. But unlike Balsan, Capel took a personal interest in her. He liked her intelligent mind and her curiosity. Sensing her interest, he shared his fascination with numerology, Eastern religions and books. When they went riding, she borrowed his clothes, and seeing how much she enjoyed wearing them, he insisted on taking her to his tailor to have her wardrobe properly made. When she said that she wasn't pretty, he complimented her on being original. Instead of sloughing off her interest in fashion as just a way of passing the time, he recognized it as the key to her future, encouraging her ambitions and pushing her to pursue her dreams. He gave her the confidence to plunge ahead. He was her "father, brother and whole family," she later said, "the great luck of my life. He formed me, he knew how to develop in me what was unique." She was madly in love with him.

But when her musings turned toward marriage, Capel thought otherwise. Kept women were not acceptable wives, at least not to the men who kept them, and he had kept quite a few. He was, however, willing to back her in business, and in doing so Capel became her cornerstone, the foundation of her phenomenal success.

The time had come for Chanel to sell her hats in Paris. Capel had an apartment on the Avenue Gabriel where they could live together, but he lacked enough space for her to work. With his usual charm, he convinced his rival Balsan to loan her his flat, not far from the fashionable Burberry's on the Boulevard Malesherbes. Later on, she would boast a bit crudely, "I was able to start a high fashion shop because two gentlemen were outbidding each other over my hot little body."

As pleased as she was to be in Paris in 1913, Chanel felt apprehensive and ill at ease, far from the world of horses and *horizontales* she had known. On the Place Vendôme or the Rue Royale, chauffeured cars lined up in front of the shops, while taxis and buses rolled along the broad streets, and under the ground the popular "metro" sped through the city. Smart showgirls and fancy actresses sat at outdoor tables in the busy cafés sipping their Vichy water, while more worldly mistresses and their men drank martinis at Maxim's. Everyone made their plans over the telephone and gossiped about the social set, discussing the dressing rooms and baths described in the new magazine *Femina*.

Fashionable crowds flocked to the Opéra, and philanthropists partied at costume balls. Patrons of the ballet were introduced to the ge-

nius of the Russian choreographer Sergei Diaghilev, whose Oriental costumes and sets seemed to influence everything from music to clothes. Theatergoers were awed by the acting of Sarah Bernhardt, concertgoers were mesmerized by the music of Darius Milhaud and the dissonant strains of Igor Stravinsky, and art lovers discussed the talents of the Spanish Cubist painter Pablo Picasso and the French Fauvist Henri Matisse. Some people even spoke about the right of women to vote.

Terrified to face society, Chanel stayed indoors—not that the refined Capel would have taken her out. She had neither the manners nor the culture of the courtesans who paraded in the Bois or dined at the smartest cafés. Yet these were the women who, wearing the high-waisted dresses or hobble skirts of Worth, Poiret and Paquin, set the style and made the fashion news.

Once, when Capel did take her to a restaurant, she ate too much and popped her stays. Her boyfriend had to help her close her dress. Chanel swore she would never wear a tight corset again. She sometimes attended the racetrack, a suitable place for both courtesans and countesses

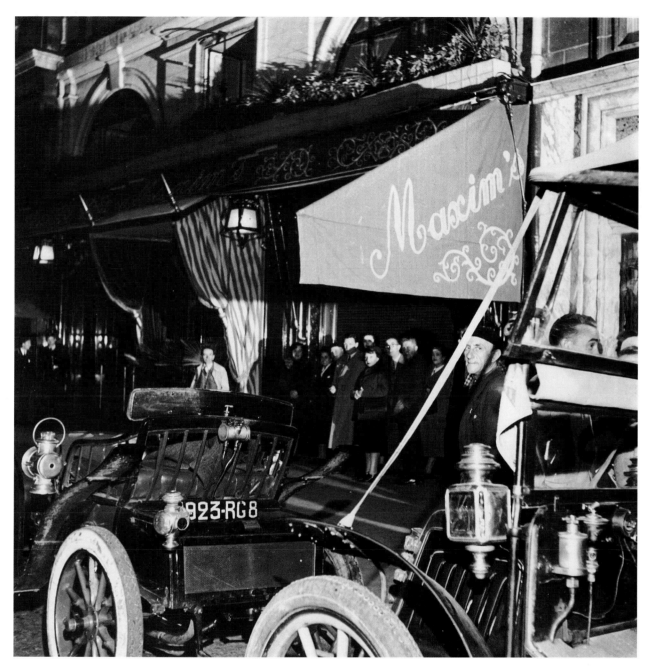

to be seen. That she was escorted by Capel aroused considerable inter-
est; that she wore distinctive hats and peculiar dresses caused a flurry of
comments; words such as "spare" and "severe" could be heard buzzing
through the crowd. By gossip and word of mouth, her identity was un-
covered.

Any mistress of Boy Capel's was worth a better glimpse, especially
one whose hats were so odd and whose look so impertinent. While she
worked night and day, the demi-mondaines arrived in the mornings at

CARRIAGES PARKED OUTSIDE
*Maxim's, one of the smartest dining
spots for sophisticates.*

IN 1913 *FEMINA* DID AN
illustration of Chanel selling her hats
in her shop on the Rue Gontaut-Biron
in Deauville.

her atelier, admittedly coming less for acquisition than for curiosity. Though at first she was shy and fearful, and hid from their view, she finally managed to come out to comment on their elaborate outfits, and to pronounce her disapproval. "How can the brain function in those things?" she sniffed at their huge hats.

Despite her churlish attitude, her success with Capel clearly intrigued the women. Even though her prices were high, her spare, young style was appealing. Chanel was confident in her work, and with the help of a woman hired by Capel to give her business advice, she quickly developed a clientele and encouraged her friends to pursue potential customers for her. From time to time, actresses and opera stars were shown in the magazines wearing her creations.

Within a few years she was able to move her shop into its own space on the first floor of the Rue Cambon, and with financial help from

Capel she opened a second store in the resort town of Deauville. This chic spot on the English Channel was a favorite of Capel's and a playpen for well-to-do British and French.

On the Rue Gontaut-Biron, the busy thoroughfare of the town, stylish guests checked into the Normandy, the great hotel overlooking the beach, and while their servants unpacked their Louis Vuittons, they strolled along the boardwalk to the opposite end. At the casino, built by the owner of Maxim's, they could watch well-known entertainers perform in the theater upstairs or see slick-haired men and well-coiffed ladies in narrow skirts tango across the downstairs dance floor. But the

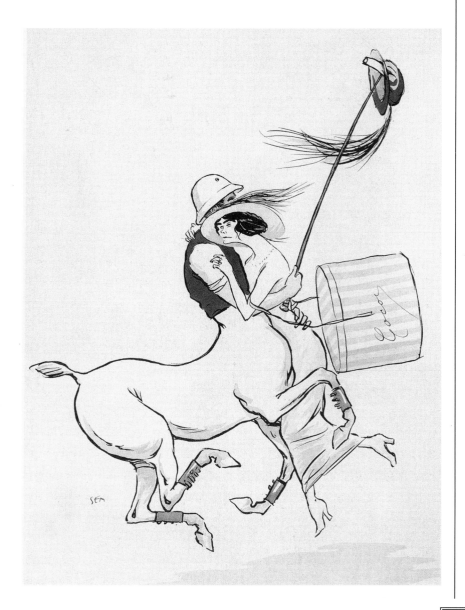

WHEN SEM DID A
caricature showing Boy Capel holding a polo mallet, a hat box and Chanel, she was on her way to fame.

main attraction was the gambling rooms where, standing alongside maharajas and sheiks, they rolled the dice or tried their luck at baccarat.

On the avenue, elegant shops supplied expensive clothes to the winners and other fashionable visitors. Henri de Rothschild promenaded in his smart white flannels, the Comtesse le Maroy fluttered by in her brilliantly colored dress, and the Marquise de Noailles flaunted her huge feathered hat. By 1913, a pretty young woman named Adrienne also sashayed along, showing off a simple hat and a plain, lined wrap coat, items from the new boutique of Gabrielle Chanel. A close friend and actually the youngest aunt of Chanel, she was hired to wear the clothes and promote them.

But the best publicity came from Boy Capel. With the youthful-looking Chanel at his side, he bet on his horses at the racecourse; and while she cheered him on, he proved his reputation as the best polo player on the fields. Adored by those in high society, he was in demand at their parties and at all their big events. Their disappointment was palpable when one evening he canceled his plans to attend a gala and was seen later at dinner alone with Chanel. The sight of the couple was a shock to the Deauville beauties. "I realized then that Boy had abandoned us for you!" one of them admitted to Chanel.

SEM CITED CHANEL FOR HER *elegant style in his book* Le Vrai et le Faux Chic.

Stories of the twosome spread around town like wildfire and soon appeared in the press. What better publicity for Chanel than to read her name in the gossip columns and see her caricature in the social sheets. When the well-known cartoonist Sem drew a sketch of Capel holding on to a polo stick and a hat box, with Chanel clinging to his neck, she could claim success. And when Sem did a series on fashion chic, crediting Chanel for inspiring elegant dress, she was on her way to fame.

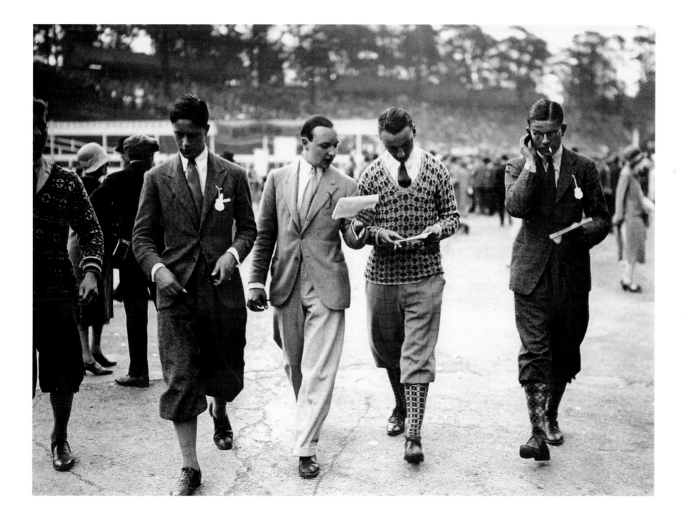

The discomfort she felt in Paris disappeared in Deauville. At the seaside resort, she relished the air and the outdoors, enjoyed meals at the finest restaurants, sold her expensive hats and even offered some accessories to the rich. As for the weather, which sometimes turned raw, she tried her best to keep warm. To ward off a chill one day, she did as she often had done in the past and plucked a sweater from Boy. But instead of pulling it over her head, to keep it from messing her clothes she took her scissors and snipped it down the front, finishing off the raw edge with ribbon and adding a collar and bow. It was a hit as soon as she put it on. Without even knowing how much it cost, other women wanted the same outfit for themselves. She sold ten almost at once. "My fortune was founded on that old jersey," she remarked dryly, "just because I was so cold in Deauville."

Practicality drove her style. The hand-knitted fabric was a far cry from the heavy embroideries or fancy taffetas, or even the wools popu-

CHANEL BORROWED THE *look of argyle sweaters and used them for her own jersey outfits. When she took a jersey sweater of Boy Capel's and cut it into a dress, it was an instant success.*

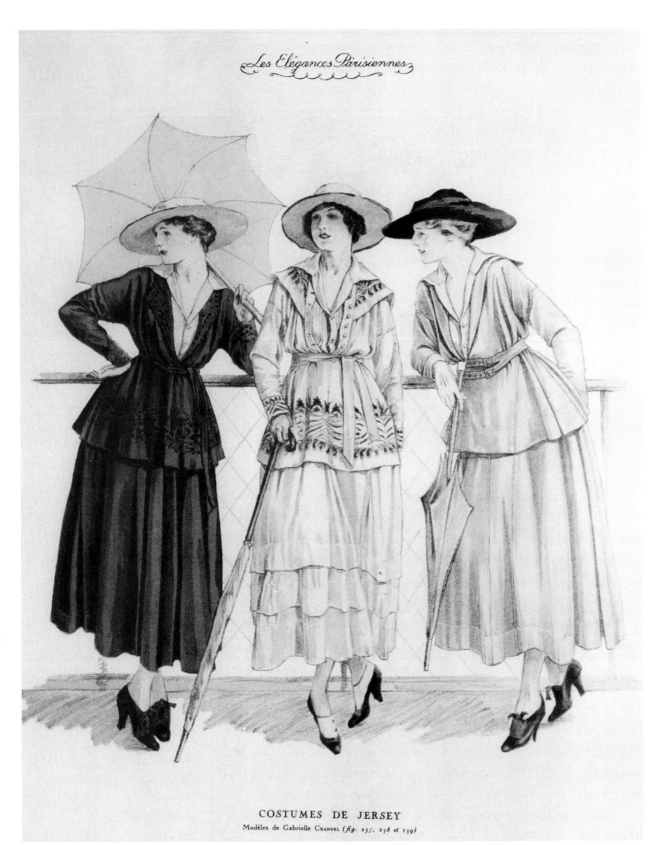

COSTUMES DE JERSEY

Modèles de Gabrielle CHANEL (*fig. 257, 258 et 259*)

lar at the time. Chanel's jersey was fluid and soft and moved as she did, allowing her body the kind of freedom she loved. It wasn't long before Chanel was using the cloth to make other clothes, especially jacket and skirt ensembles. But the hand-knit jersey was thicker than she preferred, and she searched for another version, one that was thinner and lighter. Her pragmatism led her in the right direction.

The textile firm of Rodier showed her some machine-made goods they had hoped to sell for men's underwear, and seeing them, she knew she was on the right track. The beige knit had been a failure for Rodier, and no doubt she thought that she could bargain and buy it for a good price. She announced she had found the answer to her search, and to Rodier's surprise, ordered more goods than they had on hand. When the fabric arrived, she cut it along simple lines, keeping the styles easy and spare.

While other designers' skirts were long and narrow, tight at the ankle, and topped by a knee-length tunic, Chanel's were loose and full, and shorter than the rest. Her uncluttered clothes, so different from those other constricted looks, made women feel young and sexy. They were accepted at once. The timing could not have been better: while Chanel was changing the fashion, Europeans were changing their mood.

Only a year after she opened her shop, Deauville was turned upside down. With the start of the First World War in August 1914, every man was called on to fight, and aristocrats enjoying their holiday were suddenly packing their bags and heading home. The lively spa on the sea became a lonely ghost town as houses emptied out and storefronts were shuttered tight.

At the urging of Boy Capel, however, Chanel kept her shop doors open. Capel was friendly with the French official Georges Clemenceau and the British Prime Minister Lloyd George, and because of his contacts he was gaining hefty contracts for coal. He was increasing his fortune, and he guessed that others, too, would be enriched from the war. The shrewd hunch of the financier proved to be right. An influx of profiteers from around the world soon descended on Deauville: arms dealers from Greece, beef producers from Argentina, silk merchants from China, citrus growers from Florida all flocked to the well-known resort.

As the war encroached upon the cities, well-to-do families fled their homes and returned to the safety of Deauville carrying only a few be-

IN 1916 CHANEL'S *simplified jersey styles and shorter skirts started a trend toward practical dressing.* (Les Elegances Parisiennes)

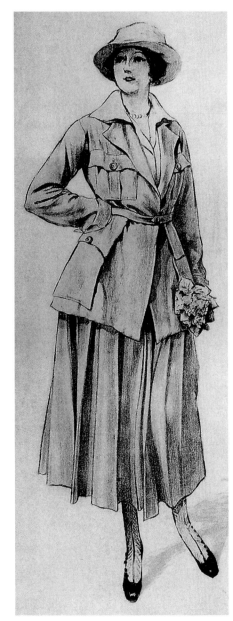

FOR WOMEN WHO WORKED
during the First World War, Chanel's safari-jacket suit was a practical approach to dressing.

longings. In desperate search of new clothes, the women headed for the scalloped white awning with black letters that proclaimed Chanel's boutique. It was the only place to go. Not even her exorbitant prices, ranging from 3,000 to 7,000 francs for a dress (the equivalent, on average, of 2,000 dollars today) stopped them from buying.

With battles raging through Europe and their men at the front, women took on a new, active role. Even the rich no longer lounged about changing their costumes with the chimes of the clock. Instead they organized for the war effort, serving as nurses or aides, doing office work for the Red Cross, collecting food for the hungry, finding jobs for impoverished wives left at home. Their new lives called for walking, biking and riding buses, and the women needed clothes in which they could move about freely. They wanted uncluttered styles that required neither laces nor stays, nor the help of servants to put on. Poiret's and Paquin's bulging bustlines, high-waisted dresses and skirts that touched the ankle were too restrictive. Chanel's fluid creations made more sense. Her outfits, pruned for practicality and cut for ease, had just the right feeling for the times.

Her fashions were so in demand that in 1915 she opened another branch, this one a couture house in Biarritz. It was located near the Spanish border, and provided a convenient shopping stop for visitors to the summer palace of the king, vacationing Russian nobility and wealthy war exploiters from neutral Spain.

On both sides of the Atlantic, Chanel was making news. The American magazine *Harper's Bazaar* showed "a charming chemise," one of the outfits from the Biarritz collection, and American *Vogue* soon followed with more spreads. A safari jacket and skirt in jersey, fur-trimmed capes and pocketed coats, all had an easy air of nonchalance. Indeed, America not only promoted her fashions, it even inspired her styles. A satin cowboy dress fringed in silk won a large feature in *Vogue*.

Chanel was becoming the leading example of the new woman. Slim, narrow-hipped and nearly breastless, she had shed her corsets, shortened her skirts, cut her long hair and allowed her youthful face to tan in the sun. She lived openly with a man she loved but was not married to, and she enjoyed financial independence as an entrepreneur with a flourishing business.

She put others in charge of her shops and soon returned to Paris

to concentrate on her enterprise. Each new problem in life propelled her to new ideas. With women no longer able to order their drivers to take them shopping on rainy days, they needed cloaks to protect them from the elements. Chanel invented a rubberized style based on the lines of a chauffeur's coat, with deep pockets and adjustable tabs at the cuffs. Amusingly done in rose or blue, or the basic black and white, its appeal was so great that one customer bought it in three different shades. And within a short time, her clothes were being bought by customers from North America to Argentina, from England to Russia.

With her workrooms overflowing, she had made enough money to pay back Capel. She moved out of the apartment she shared with him, into a place of her own on the Quai de Tokyo. She also moved her shop a few doors down, from 21 to 31 Rue Cambon. It was 1919, and, Chanel said later, she "had woken up famous." At thirty-two, she was on top of the world.

Chanel had always known that Capel was a man with a wandering eye. Although it did not please her, it was a fact of life that she accepted. If she could not have him completely, at least he was hers most of the time. But when business interests and his work in British Intelligence took him back to London, Capel made a dramatic change in his life. No longer satisfied with having a string of lovers, he set himself on a search for a wife. Toward the end of the war, the much-sought-after bachelor announced his plans to marry. His fiancée was Diana Wyndham, daughter of a British lord. His rejection desolated Chanel.

The warning signs had been there all along; Capel was a man on the rise, and she had neither the class nor the wealth to help him. Save for a few things like a topaz ring set in gold that she kept all her life, she told friends she returned the gifts he had given her. Whether or not she did, she felt betrayed; nevertheless, she did not willingly give him up. Nor did he want to break the bond between them.

In spite of his wedding, and the birth of a daughter less than nine months later, on his trips to France Capel continued to see Chanel. And she continued to encourage it. Two days before Christmas in 1919, he bid her good-bye at her house near Paris, setting off in his sports car to spend the holiday with his wife in the South of France. But while driving along the road to Cannes, one of the tires burst, and the car crashed. Though his chauffeur was only injured, Boy Capel was killed. The news of his death was devastating.

STORM-PROOFING THE PARISIENNE

By Force of War and Weather, the Utilitarian Rubber Coat Rises to Distinction

By JEANNE RAMON FERNANDEZ

Sketches by Georges Barbier

WAR and the lack of motors has brought into prominence a garment which, while not indeed new, has none-the-less assumed new forms in honour of its admission into the wardrobe of the woman of fashion. This garment is the rubber coat, which, despite its origin of humble usefulness, has, by force of circumstance, become a very distinguished costume. Those women who took active part in the work of the Y. M. C. A. and kindred war organizations early adopted the military rubber coat in blue or khaki rubber cloth. Seeing this, the woman of fashion, even though not engaged in war work and not, as a rule, obliged to go out in the rain, decided that she also must have her rubber coat. Even though such a garment was not a requirement of her daily life, she could at least find a use for it on the beach or in the country, when she went out to face the storm and let the wind and rain lash her pretty cheeks to a rose tint not to be found in any *salon de beauté*.

CHANEL MAKES RAINCOATS

Chanel, in particular, has devoted much time to the making of engaging rubber coats, white, rose, blue,—of all colours and in every form, but always practical, easy to wear, and fastening close and high at the neck. Among the Chanel models is the coat of brilliant black rubber, on the lines of the coachman's or chauffeur's coat. This coat narrows slightly toward the bottom and has two great pockets at the sides; the collar consists of two straight scarf-ends about twelve centimetres

The rains may descend and the floods come, but the Parisienne defies them; gloves, hat, coat, and boots, all are weather-proof

wide, which are crossed in front and thrown back over the shoulders, falling down the back. A belt of the same width fastens with two buttons, either very low or very high, according to the fancy of the wearer. A loose tab with one or two buttons fastens the sleeve at the desired width. I know one woman who has three rubber coats of different colours cut on exactly these lines. Yet another form adopted by this newly smart garment is the soft rose coloured rubber coat with a collar ending in two points which fall down the back weighted with tassels.

THE PARISIENNE AS MÉNAGÈRE

After all, even the woman of fashion has real need of these garments to-day. There are so many material questions which come to distract her attention from those intellectual delights which make up her life. Must she not in these days even go to the markets to order the household milk and fruit, under penalty of being reduced to living on boiled potatoes exclusively?

For these journeys to the market, could she consider wearing her elaborate frocks or even her simplest tailored costume, especially if it rains— and it always does rain. The ideal garment for these essential outings is the rubber redingote, blue, green, or black, in which she may walk in comfort untroubled by the awkward umbrella. Its great collar protects her throat; her little hands are thrust in its great pockets; and her hair is protected by a little hat of matching oilcloth. Could any garments be more practical?

papillon et chrysalide.

(Left) When half the dripping length of the Champs Elysées lies between one and tea at the Ritz, with never a taxi to bridge the gap, this is the French solution

(Right) Those joyous souls who are still twenty-one, adopt and adapt the famous greatcoats and the picturesque caps of the Paris car-starter and the mountain shepherd

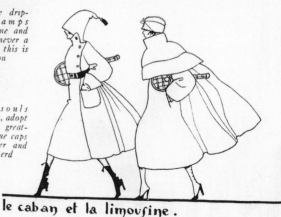

le caban et la limousine.

ALWAYS PRACTICAL, CHANEL
was one of the first to show rubberized coats for the rain. She adopted her styles from the cloaks of chauffeurs.

First her father's disappearance, then Capel's death. For the second time, Chanel had lost the most important man in her life. Just as financial success seared through her soul, abandonment scorched her heart. The tragedy of Capel's death left her despondent. If her father had teased her with a taste of love, Capel had nourished her with a feast of

loving and being loved. He had opened up the magical world of books and the mystical world of Eastern religion. He had shown her her own strengths and pushed her to be confident in herself. He had told her always to remember she was a woman. He had educated her in the fundamentals of business and taught her the rudiments of finance, and by the time of his death her shops were earning enough to make her self-sufficient. And when his will was announced, he showed her that he had always cared: he'd left most of his fortune of seven hundred thousand pounds (about twenty million dollars today) to his wife and child, but had set aside forty thousand pounds (more than a million dollars) to Gabrielle Chanel.

She would never love another man as much as she had loved Capel. Throughout her life she referred to him as the only man she ever cared for. Wherever she went, whomever she met, she could almost always trace the experience back to him. There might be other men and other romances, but she had learned from him that passion was far less important than "warmth, tenderness, affection, understanding." Feeling isolated and forlorn, she resisted her friends and redoubled her efforts at work.

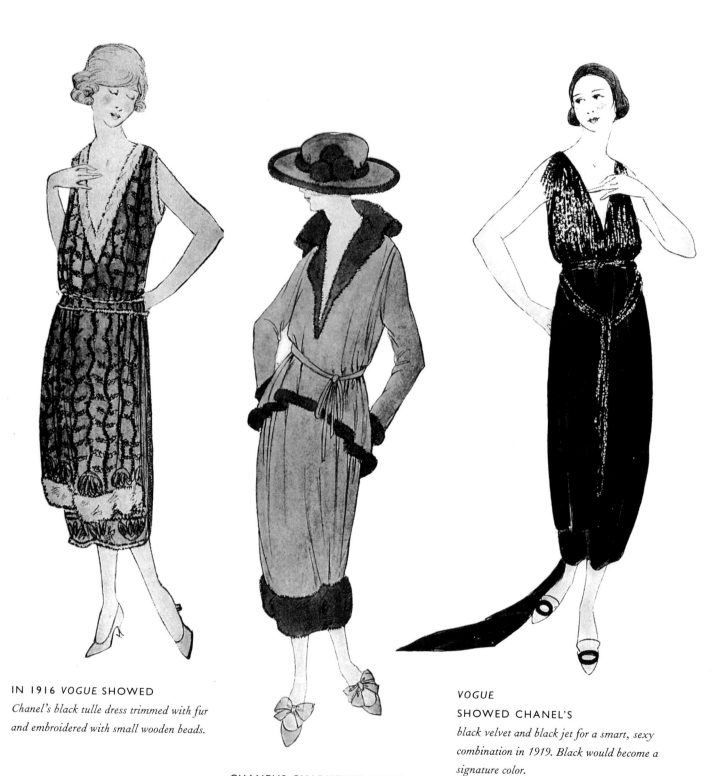

IN 1916 *VOGUE* SHOWED

Chanel's black tulle dress trimmed with fur and embroidered with small wooden beads.

CHANEL'S CHARMEUSE DRESS

trimmed with fur was shorter and softer than the styles of her 1916 competitors Patou and Paquin.

VOGUE
SHOWED CHANEL'S

black velvet and black jet for a smart, sexy combination in 1919. Black would become a signature color.

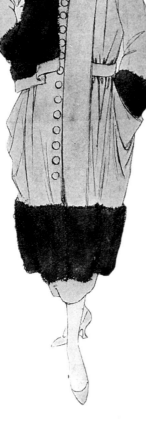

CHANEL'S JERSEY
*shirtwaist dress with pockets
and button trim was a perfect
dress for the career girl.*

IN 1916 THE AMERICAN
*cowboy inspired Chanel to
create a black satin coat fringed
with black silk and trimmed
with a handkerchief tie.*

CHANEL LOVED DEEP
*pockets to poise the hands, and
rows of buttons to set off her
clothes. In 1916 she trimmed
this brown velvet coat with
Peruvian fur.*

THE FRAGILE GOWN OF
*black Chantilly lace trimmed
with black jet was shown in
Vogue in 1919.*

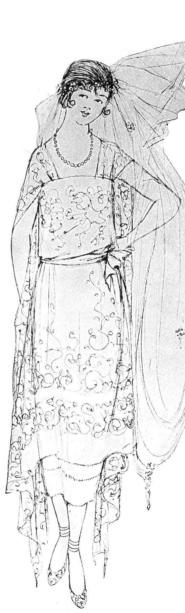

CHANEL LOVED THE
*feminine look of lace for late
day and evening. This tiered
dress and jacket-shaped bodice
were done in 1919.* (Vogue)

THOUGH SHE SHOWED THIS
*white Chantilly lace wedding dress in
1919, Chanel herself never became a
bride.*

CHANEL'S SOPHISTICATED
*velvet coat with fur trim and deep
pockets was shown in* Vogue *in
1919.*

Theatrical Attachments

IN ONE WAY OR ANOTHER, the theater always played a role in Coco's life. From her earliest days in Moulins, where she tried her best as a singer, to the years at Royallieu, where performers first wore her hats, to her friendships with actresses and her dreams of being a star, she was eager to surround herself with personalities from the stage. Years before, in Paris, she had asked to meet Cécile Sorel, an actress endlessly written about and frequently illustrated. Undoubtedly wanting to win her as a client, Chanel had pressed Boy Capel, who knew *everyone,* to introduce them. In the spring of 1917, an invitation arrived to dine with the flamboyant Sorel.

At the actress's celebrated apartment on the Quai Voltaire, the setting was appropriately dramatic: leopard-skin rugs sprawled across the marble floors, and leopard-skin curtains hung from the windows. In the drawing room, blue and gold boiserie covered the walls, rows of tooled-leather books filled the shelves, a

THE THEATRICAL STAR
Cécile Sorel was well-known for her flamboyant style.

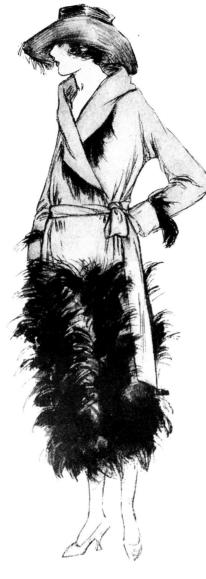

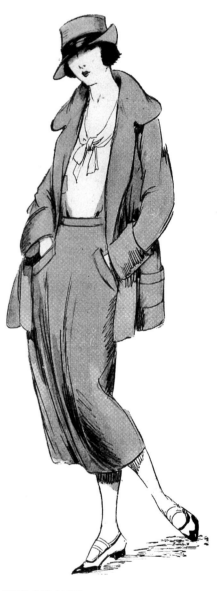

AFTER A DINNER AT THE
home of Cécile Sorel, the actress
became a client of Chanel's. She wore
this striped tunic dress in L'Abbé
Constantin *in 1918.*

CHANEL LOVED TO USE FUR
to trim her clothes. Here she shows
monkey on the skirt and cuffs of a red
velvet wrap front coat, in 1920.

THE RELAXED BEIGE JERSEY
suit, with a deep-pocket skirt and
easy jacket, a typical Chanel look,
shown with a soft-bow blouse, simple
hat and two-tone shoes.

Coromandel screen stood in the corner, and a chaise in the shape of a gondola joined an array of antiques. Chanel was not impressed. With her critical eye and sharp tongue, she described it to a friend: the silver lacked sheen, the furniture was unpolished, "the rough paneling seemed like plaster, the gold tablecloth wasn't gold, and, it was dirty." Nonetheless, she admitted, she liked her hostess, a star of Moliere comedies; and the other guests, such as the writer Jean Cocteau, the muralist José-Maria Sert, and his mistress Misia Edwards, were hardly dull.

If Cécile Sorel was an important figure of the stage, Misia Edwards was a central figure in the artistic life of Paris. She was born into an aristocratic Polish family of musical legend and herself was a talented pianist, as well as an ebullient hostess who entertained poets, writers, painters and musicians. The essence of the Belle Epoque woman, her forceful personality served as a model for authors, and her rounded beauty made her a muse for some of the most brilliant artists of the day. Marcel Proust used her as the basis for his character Princess Yourbeletieff in *Swann's Way*. Toulouse-Lautrec, Renoir, Vuillard and Bonnard begged her to pose for them, and today their paintings of Misia hang in museums around the world.

She was well known for her charm and flirtatiousness, and had carried on a romance with her wealthy cousin Thadée Natanson that eventually led to marriage. While married to him, she became the mistress of the newspaper magnate Alfred Edwards. But after her second marriage, to Edwards, she fell in love with the Spanish artist José-Maria Sert, and left Edwards for him. It was just before her third marriage, to Sert, that she and Chanel met.

Sitting across from each other at the dining table, on the bright red chairs that punctuated the room, Chanel had attracted Misia with an almost mystical power. Though quiet, seemingly shy and not yet well known, Chanel's obvious style and sharp intelligence intrigued the older woman. As the dinner progressed, Misia could hardly take her eyes off her. And by the end of the meal, when the

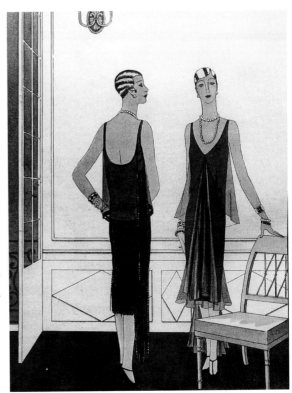

THE SEVERE LOOK OF THE
1920s gamine meant short slicked hair and short shapeless frocks, like this Chanel dress in black mousseline.

THE CHANEL DRESS ON THE
left has three tiers and a soft jacket. Her ensemble on the right has a typical Chanel touch, a dress that matches the lining of the coat.

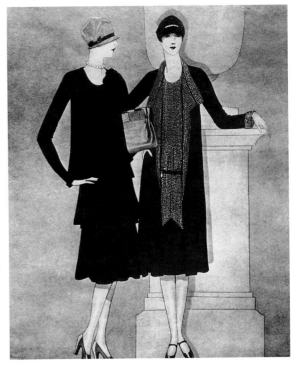

ABOVE, LEFT: **IN 1916 VOGUE**
*showed Chanel's dramatic Bordeaux-
red tiered jersey wrap trimmed with
brown rabbit.*

ABOVE, RIGHT: **MISIA SERT**
*was a muse for leading painters of
the day. This 1904 portrait of her by
Renoir hangs in the Tel Aviv
Museum.*

OPPOSITE: **AT THE 1925 OPERA**
*Entrances Ball, Misia Sert and the
Count de Beaumont came dressed in
costumes from* The Merry Widow.

guests were ready to leave, she slipped her own fur-trimmed, red velvet coat, which had been shown in *Vogue*, onto the socialite's shoulders. The evening became a turning point for Chanel. She succeeded in winning Sorel as a client, creating the jersey dresses she wore in the play *L'Abbé Constantin*, but far more important, she forged a powerful friendship with Misia.

Outgoing and autocratic, Misia liked nothing better than discovering new talent and bringing it to the fore. One of her closest friends was Sergei Diaghilev, the magnetic Russian impresario who had introduced the Ballets Russes to France. Gossip was a mainstay of their friendship, but neither of them thrived on scandal alone. The larger-than-life Diaghilev, with his swirling capes and sweeping imagination, was having a profound influence on the worlds of dance, music, set designs, costumes and fashion. Misia had put herself in charge of his dazzling corps of artists, and had given them moral and financial support. In effect, with her intriguing personality she reigned over the small group, playing the part of their public relations agent during the day, and that of their hostess at night. And she made it her business to see that their work received

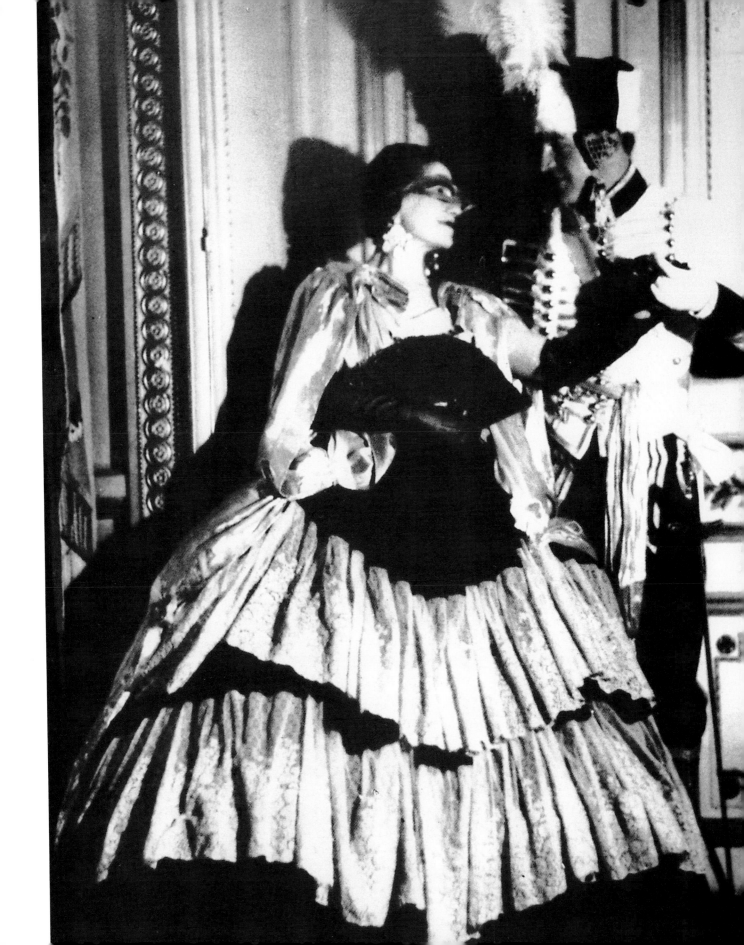

the attention it deserved. Sensing perhaps the genius of Chanel, she was determined to pursue this new friendship at once.

The two women became instant companions. José-Maria was shocked at the fascination his lover showed with this other woman, who seemed so different from Misia. The day after dinner at Cécile Sorel's, Misia had rushed to the Rue Cambon to visit Chanel in her shop, and that evening Chanel invited Misia and José-Maria to her apartment to dine with her and Boy Capel. As the months had worn on and Capel returned to England for longer and longer stays, Chanel spent more and more time with Misia, enthralled with her new friend. Slowly, she moved away from the world of rich men and racehorses toward the world of the arts.

But soon after the death of Capel, Chanel retreated into herself, spending her time alone. For months she sank deeper into despair, until the Serts, hoping to raise her spirits, invited her to join them on their honeymoon. It would be the first vacation Chanel had taken in several years; with a "yes" from her, the trio set off for Venice. The extravagant

LEFT: **THE DASHING IMPRESARIO**
Sergei Diaghilev brought the Ballets Russes to Paris and had a major influence on all of the arts.

RIGHT: **CÉCILE SOREL WAS ONE**
of the best-known actresses in France. It was at her apartment that Chanel first met Misia Sert.

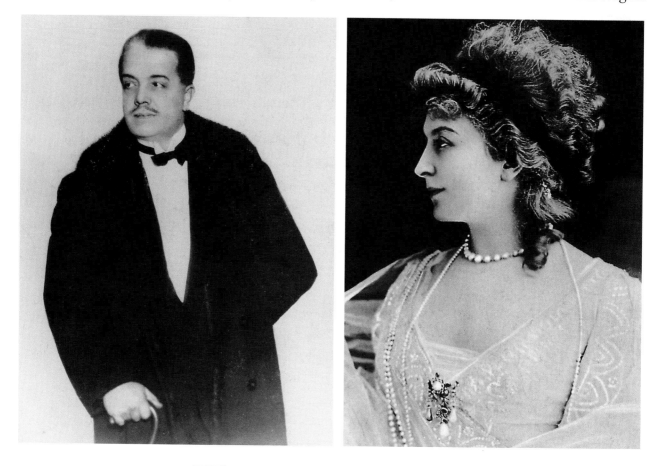

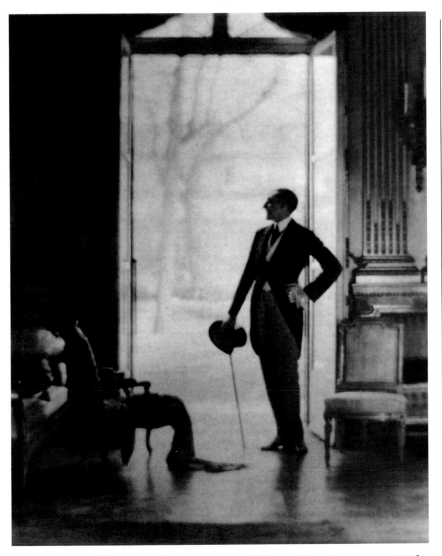

José-Maria—whose works were commissioned by Sassoons, Roth-schilds and Phipps, and whose murals still decorate the walls of the Waldorf-Astoria and Rockefeller Center in New York—served as her guide. In his thick Catalon accent he expounded upon the beauty of the buildings, and with his wealth of information he made the paintings come alive. The exuberant Misia acted as director. Together they took Chanel from one museum to another, one restaurant to the next, all the while educating her about art and the art of living.

At one well-planned dinner that the Serts held in her honor, Chanel was introduced to the smartest people Misia could find: the Prince of Greece, the Countess Volpi and others; all of them witty, well-dressed, well-connected. And one evening in a café along the canals, the Serts encountered Diaghilev, who, having noted that Chanel was pretty, com-

plained aloud about the lack of funds to restage one of his favorite ballets. They also met the brilliant composer Igor Stravinsky during their stay. Slowly, Chanel pulled out of her depression.

Back in Paris, Misia brought Chanel into her inner circle. The clique included the arts patron Count Étienne de Beaumont, the playwright Jean Cocteau, the painter Pablo Picasso, the poet Pierre Reverdy, and of course, Diaghilev. It was Chanel's own generosity that ingratiated her with the impresario. Remembering his anguish over not being able to produce a certain ballet, she took it upon herself to help him out. Unannounced, she visited Diaghilev at his hotel and wrote a check to cover the cost of *Le Sacre du Printemps*. The only string she attached was that he could not tell his friends that she had given him the money. Her surprising act of magnanimity was something Diaghilev never forgot.

Although her generosity undoubtedly made her even more attractive, she was accepted by the artists almost at once. Theirs was a stimulating world where creativity charged the air and intellectual notions challenged the mind. The war had shattered earlier ideas of reality, and the artists' responses of Dadaism, Surrealism and Cubism were understood by Chanel. Her minimalist approach to fashion was not so far from their abstract ideas of art. As much as she enjoyed being with the avant-garde, they enjoyed her company. They never questioned her credentials, never cared whether her lineage was aristocratic or indigent. The only things that counted were talent, wit and intelligence. She had all three.

But if the artistic world was accessible, the tightly knit world of French society was not. Misia served as Chanel's publicist and friend, securing invitations for her presence at all sorts of parties, but the coveted costume balls were beyond reach. These lavish affairs, given by aristocrats and attended by all the "best" people, were meant to amuse the elite; couturiers were not even considered. The balls were events of giant proportions; months of preparation went into the extraordinary settings, the extravagant costumes, the elaborate food and even the choreographed entrances of the guests.

When the Count and Countess de Beaumont called upon José-Maria Sert to design the decorations for one of their fancy dress balls, they even asked Chanel for some ideas. But when the invitations went out, Chanel's name was not on the list. To them, a couturier was merely a purveyor of clothes, a tradesperson, not a patrician or a peer. On the

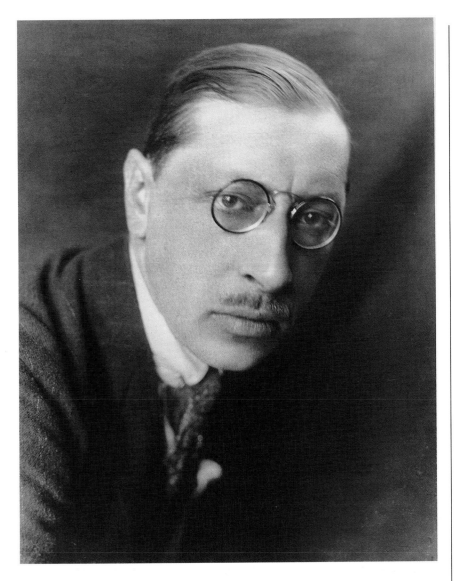

THE COMPOSER IGOR
Stravinsky pursued Chanel while he was married and became one of her lovers.

evening of the big event, Misia loyally refused to go to the gala without her. Instead, the two women stood outside, observing the guests, gossiping about everyone who attended. But if Misia was entertained, Chanel was not amused at being left out. It took only a year or two before she became a regular invitee, one of the first fashion designers to be accepted in high society.

Misia did invite Chanel to a favorite nightspot, Le Boeuf Sur le Toit, a small, noisy bar in Montparnasse where a black band played Mozart and jazz, and the regulars drank and table-hopped as though they were in their own private club. Started by Jean Cocteau, it was a gathering place for Diaghilev, the composers Eric Satie and Darius Milhaud, the dancer Serge Lifar, the writers Cocteau and Maurice Sachs, and aristo-

CHANEL SURROUNDED

herself with creative personalities. Here, dressed in trend-setting evening pants, she is with the dancer/choreographer Serge Lifar, the Countess de Noailles, Igor Stravinsky and Vera Sudeskin.

crats such as the Prince of Wales and the Count de Beaumont. Once in a while Diaghilev's lover, Nijinsky, came by, and so did the sullen poet Reverdy and his close friend Pablo Picasso.

Chanel was drawn to the virile Spanish artist, awed by his piercing eyes and his powerful presence. She dreamed of being his mistress, but her attempts were unsuccessful. Recently married to Olga Koklova, one of Diaghilev's pretty dancers, he was too involved with his wife to pay Chanel much attention. Nevertheless, he became a patron later, when

his spouse started shopping at her boutique. And once in a while, when his wife was out of town and he was feeling lonely, Chanel would lure him to her apartment. She never lost her admiration for Picasso. Referring to him as "a great friend," she venerated his drive and determination, visited his studio often, and remained his crony for twenty years. As for Picasso, he called her "the woman with the most sense in Europe."

Instead of the Spanish painter, it was the Russian musician Stravinsky who, Misia noted, "fell desperately in love with her." When they met, he was already well known for his works *Firebird*, *Petrushka*, and *Le Sacre du Printemps*, and he remarked upon Chanel's attractive looks and inquisitive mind. Soon after, in a bountiful gesture, she loaned him her house in Garches, where he moved with his wife and family. And although he was shy and timid, by the autumn of 1920 he was seeing her every day, teaching her about music, telling her about Russian life. In truth, he was courting her.

And his persistence won out: Chanel succumbed to his desires. When she told him she was concerned that his wife might find out, he told her that she already knew. To whom else but his wife, he asked, could he confide something so important? The love affair lasted only a brief while. In the end he gave her a pair of cuff links and a precious Russian icon, and while he went back to his family (at least for a little while), she went off with another man, taking credit for turning the composer from a naive émigré into a man of the world.

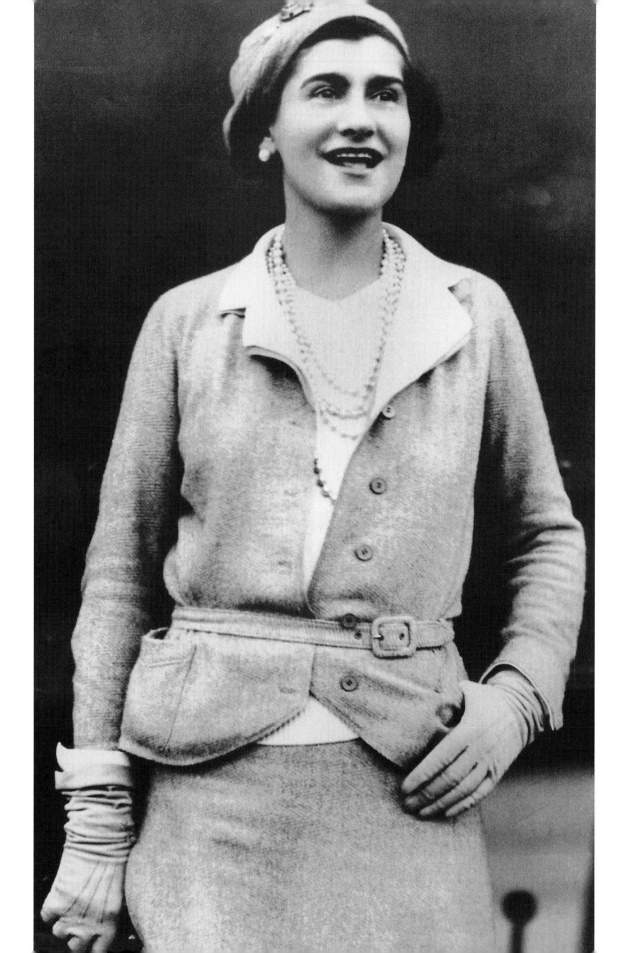

Russian Airs

INTIMATE LIAISONS WITH ARTISTS, and love affairs with elites: Chanel wavered between the two. Pushed by a hunger for knowledge and a need to create, she pursued poets, writers, painters and musicians. Pulled by a lust for money and a yearning for luxe, she was drawn to aristocrats and the upper class. It was after a chance meeting in Biarritz with a friend, the singer Marthe Davelli, and while she was still seeing Stravinsky, that Chanel's interest in the higher ranks was restirred. The man accompanying Davelli was Dimitri Pavlovich, a dashingly handsome grand duke. When she saw Chanel eyeing her lover, Davelli complained that Dimitri was costing her too much money to keep. Chanel could have him if she wished.

Surrounded by an aura of mystery, Dimitri had the smooth looks and elegant manners of the men Chanel had read about in girlish novels. He was a former member of the elite Russian horse guard, and was known to be one of the three assassins of the Czar's adviser Rasputin. The Grand Duke was an intriguing figure, eleven years

FRISKY AND FLIRTATIOUS, *Chanel moved between aristocrats and intellectuals, choosing her boyfriends first from one group, then the other. She is wearing a favorite suit look— belted, cropped tweed jacket with patch pockets, double lapels and turned-back cuffs; and matching skirt.*

47

younger than she. Ignoring her friend's warning, Chanel made her move. Her adoring looks, soft purrs and sinuous moves seduced him. Turning her back on Stravinksy, she invited Dimitri to join her for a drive to Monte Carlo. He gladly accepted.

The Grand Duke had been raised by English nurses in a vast St. Petersburg palace. He was the grandson of Czar Alexander II, as well as the first cousin of Czar Nicholas II. He had the taste and style of a true aristocrat, and had been one of the richest young men in Russia. But the assassination of Rasputin had enraged the Czar, and under the ruler's orders, Dimitri had been forced to flee his country. Though he managed to stash away a treasury of precious jewels, he left with few rubles to spare. By now he was nearly penniless.

The summer they met, Chanel leased a house at the beach near Bordeaux where they pleasured together, dreamily going from the ocean during the day to the gambling casinos at night; and while she provided him with smart clothes and a luxurious habitat, Dimitri plied her with ropes of fabulous pearls, chains of heavy gold, and crosses encrusted with rubies, emeralds and semi-precious stones. Like a scene from a Diaghilev ballet, the jewels, the furs, and the polished manners sparkled memories from another world. Dimitri's Russian influence would soon inform her work.

Adorned with Dimitri's gifts, she was shown in *Harper's Bazaar* wearing a short dark tunic, pleated skirt and a mass of "dazzling" pearls. The editors credited her with "making simplicity, costly simplicity, the keynote fashion of the day." In her showroom, svelte Slavic girls with high cheekbones and good connections started modeling, kissing Dimitri's hand and calling him "Majesty." And others, selling to clients, carried Russian titles—evidence to her customers that the name Chanel was synonymous with class. An inveterate snob, she persuaded the strikingly tall Iya Abdy, daughter of a famous Russian actor, to serve as her liaison to society. It

was a publicity ploy Chanel practiced throughout her career: while she preferred to spend her evenings at home, following a strict regime of early-to-bed and early-to-rise, she sent well-chiseled ladies with social credentials, dressed in Chanel clothes, to dine at the best restaurants, attend the best parties and promote her name.

The Russian influence went further. Dimitri's sister, the Grand Duchess Marie, formerly dressed by famous couturiers, now, like others, was living in exile and in desperate need of funds. Taught to sew as part of her proper education, and skilled in the art of embroidery, she was hired by Chanel. With the assistance of a handful of able friends, she established a separate workroom, and delivered embroidery and beadwork at far less cost than that demanded by French seamstresses. (At the same time, she was providing the only source of income for her friends' émigré families.)

The once-wealthy women, now at the edge of despair, were inspired by Chanel's unstoppable vision. They began by embroidering blouses and traditional Russian tunics, and soon expanded their efforts to jackets and coats worked with passementerie, and to evening chemises studded with bugle beads and pearls. As the embroidered look became more popular, they expanded their vocabulary to include patterns copied from Chinese vases, Coptic weaves, Oriental rugs, Indian jewelry and Persian miniatures. New fabrics were also introduced, and when Chanel showed her clients the first crocheted chenille hat, made by the Grand Duchess Marie, the look took off. Although jerseys remained a staple of her fashion house, Chanel's Russian looks became so big that, in addition to designers and technicians, the workroom increased to fifty seamstresses. For many Chanel clients, these styles were among their favorite clothes.

Whatever the workroom produced, of course, was under the discriminating eye of Chanel. No matter what aristocratic titles her employees held, it was Chanel who reigned supreme. Her wish was obeyed, her orders prevailed, her word overruled all else.

From the moment she arrived at work in the morning, her head

THE GRAND DUKE DIMITRI
was exiled from Russia by his cousin the Czar because he was one of the assassins of Rasputin.

OPPOSITE: **LIKE MANY OF**
Chanel's lovers, the Grand Duke Dimitri enjoyed horses and polo. He had been a member of the Russian Imperial Horseguard.

THE CASINO (LEFT) AND THE
*Hôtel de Paris in Monte Carlo, where
Chanel liked to vacation. When she
met the Grand Duke Dimitri, she
invited him to join her there.*

proud and high, her jaw firmly set, she was in command. Dressed in her usual outfit of a dark skirt and sweater, she climbed the three flights of steep, narrow stairs to her ateliers, rolled up her sleeves, sat down on a cushion on the floor and, lighting a cigarette, began to work. No sketches, no patterns preceded the design of the clothes. Instead, working directly with shears and pins and a sharp sense of color and line, she determined the outcome. Her eyes glaring intensely, she snapped a quick hello to the model who came before her, and with her scissors on a ribbon around her neck and her fitting assistants close by holding pins, she blotted out everything else and concentrated on the clothing. Cutting here, snipping there, pulling and pushing the cloth and sometimes stabbing the model with the pins, she made the outfit take on the exacting look of Chanel. No one else dared say a word while Mademoiselle, as she was always called at work, expounded in her staccato stream, calling out her commands, pronouncing her opinions.

From the start, Chanel was completely in charge of her collections, and if, indeed, everything she did was not original, her clothes had the authority of her conviction. Stealing a look here, an idea there, she in-

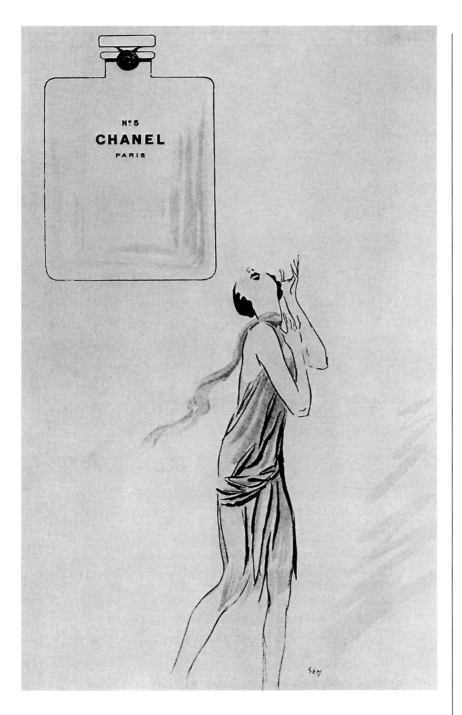

CHANEL NO. 5, DRAWN HERE *by Sem, became one of the world's bestselling fragrances.*

CHANEL NO. 5, DRAWN HERE *by Sem, became one of the world's bestselling fragrances.*

DIMITRI'S RUSSIAN *background inspired Chanel's peasant dress, shown here with pearls.*

terpreted them in such a way that they emerged with the stamp of Chanel. It was only natural, then, that she would be inspired by the Russian use of furs. Never a friend of the cold, she had trimmed her outfits with furs from the very beginning. But now she added, along with leopard, monkey and fox, an array of Siberian skins such as sable, ermine and mink, using them in fur-lined coats and lavish fur trims,

CHANEL'S EMBROIDERIES
*included designs with an
Oriental flavor.*

CHANEL HIRED EXILED
*Russian aristocrats, who created
exotic embroideries and beadwork for
her dresses.*

WHEN CHANEL SHOWED A
*knitted chenille cap done by the
Grand Duchess Marie, it was an
instant success.*

CHANEL'S RUSSIAN-INSPIRED
*peasant dress has a tunic top with a
square neck and elbow-length sleeves*

sometimes embellishing the look with embroidery. The stunning combination of needlework and fur caused Baron de Meyer, the prominent columnist and photographer, to gush in the pages of *Vogue* over Chanel's own white coat, embroidered and trimmed with Russian sable.

In their fairy-tale year of love, Chanel and Dimitri traveled together to their favorite spots, and on a visit to Venice, her Russian lover pointed out Byzantine jewels similar to the ones he had given her. The Cathedral of St. Mark's had a treasure chest of Maltese crosses studded with colored stones, as well as brilliant earrings and necklaces that harked back to the glory of Byzantium. Inspired by the rough gold and

THE FABULOUS PEARLS FROM
Dimitri inspired Chanel to do imitations later on.

the large gems, Chanel tucked away the ideas. She would use them later for a new concept in jewelry.

But Dimitri's most important contribution to her success was of a more ethereal nature. Through his Russian connections, in 1920 he introduced her to the chemist Ernest Beaux, who had been a perfumer to Czar Nicolas II. When Chanel asked Beaux to find her an innovative scent, the fragrance maker went to work in his laboratory in Grasse, trying one formula after another. After several attempts, he hit upon a recipe that pleased Chanel. He had mixed together more than eighty florals, combined them with an expensive jasmine note and, for the first time ever, intensified the natural potion with the use of synthetic chemicals. The result was a fresh and lively scent that lasted far longer than other perfumes; youthful yet enigmatic, it had an almost universal appeal.

Chanel knew, however, that scent alone was not enough to make the fragrance a success. With her skill at marketing, she oversaw the creation of a modern form of packaging: instead of the ornate flacons that had been used in the past, she borrowed from the toiletry cases of her lovers and introduced an androgynous style. The strong square bottle and solid rectangular stopper contrasted with the delicate fragrance. And in place of the old-fashioned names that other designers used, she gave hers an authentically contemporary air, dubbing it "No. 5." By presenting the new perfume at her spring show on the fifth day of the month, she increased the perception that five was her lucky number (and, indeed, its success made it her lucky number). Or was it the chemist's fifth try? The mysterious origin of the name only added to the perfume's cachet. But perhaps most significant of all, she did what no designer had done before: she attached her own name to the product.

The fitting rooms and the salon on the Rue Cambon were sprayed with the new scent. And when Chanel handed out small bottles of the perfume as gifts to her socially prominent friends, she produced a mar-

keting coup. The women who wore it clearly belonged to a rich and exclusive club, and with others eager to join them, she created an instant status symbol and a ready demand for her expensive new fragrance. Chanel No. 5 would give her economic independence for the rest of her life. Yet, even as society women clamored for her perfume, Chanel was pursuing other ideas.

Poetic Imagery

BY 1922 the word on everyone's lips was *garçonne*. The year's most scandalous bestselling novel, written by Victor Margueritte, featured a tomboy with cropped hair, flat figure and angular clothes who had an independent bent and an almost arrogant air. "The Bachelor Girl" refused to marry her family's choice of a husband and opted instead to make her own way in the world. In her search for independence, she took up work as an interior decorator and built a successful career. But in her quest for freedom she challenged more than conventions of financial support. She bobbed her hair, arched her eyebrows, rouged her lips and painted her nails. She experimented with opium, sniffed cocaine and carried on a love affair with another woman. Only after testing the limits of liberation was she willing to settle down with a man. Her sharp mind, boyish look and rebellious spirit drew controversy around the world. The book seemed to be inspired by Chanel.

Already a recognized personality, Chanel was also the subject of a book by Paul Morand. *Lewis and Irène,* a novel

CHANEL SHOWS A *hand-knit cardigan over a patch-pocketed shirtdress.*

based on her love affair with Boy Capel, described its heroine as a shrewd, successful businesswoman. Yet when *La Garçonne*'s author wrote that his character "thinks and acts like a man," the notion must have offended Chanel. The designer reacted with fury when she was told by her friend Cocteau that she had a masculine mind. Defiantly, she tied a ribbon around her head and knotted it with a bow. Not only was she far from masculine, she implied, she was as feminine and flirtatious as a little girl. The action was spontaneous but the headband and bow became part of her style. Chanel may have believed she was equal to any man, but she never confused the two sexes. Parity was important, but femininity was an imperative.

The popularity of *La Garçonne* seemed to underscore the success of Chanel. Her modern look was the essence of independence: her couture collections, featuring short, narrow chemises, were selling well, and her innovative perfume had been an instant hit. To celebrate her achievements, she had her portrait done by the sculptor Jacques Lipchitz, who produced an almost classical head in bronze, and a few months later she commissioned her client Marie Laurencin to paint her picture (the portrait now hangs in the Louvre). She drove a blue Rolls-Royce, owned a house in the country and moved from a temporary suite at the Hotel Ritz into the first two floors of an impressive eighteenth-century mansion on the Faubourg Saint-Honoré.

With the help of a friend, the writer Maurice Sachs, who filled her shelves with handsome leatherbound books, and Misia and José-Maria Sert, who advised her on purchases of art, she decorated the flat with a

OPPOSITE: **ONE OF CHANEL'S** *signature looks was the blouse or dress that matched the lining of the coat.*

ABOVE, LEFT: **THE CARDIGAN** *jacket with a self-tie collar was a favorite of Chanel's.*

ABOVE, RIGHT: **FROM HER** *early days as a designer, Chanel liked the look of a knit cardigan jacket with a jacquard skirt.*

CHANEL'S LOVER THE POET
*Pierre Reverdy was a close friend of
Picasso's. His gravelly voice and
grave poems had a somber note that
Chanel understood.*

masterful touch. Using a color scheme of white, beige and bittersweet brown, she created such an aura of richness and comfort that when Cocteau later stayed in her guest room, he described the flat as "a palace." Vases of white flowers were placed on carved and gilded furnishings; capacious Louis XIV chairs upholstered in white velvet stood in front of twenty-one Coromandel screens glowing with dark Oriental lacquer. The luxuriousness of the interior was rivaled only by the luxuriant gardens outdoors: beyond the terrace and the stone steps were a fountain and an allée of ancient trees extending back to the Avenue Gabriel.

The beauty of the apartment served as a lure for bringing in friends.

"Solitude," she said, "destroys a woman." As a patron of the avant-
garde, she attracted artists, writers and musicians, and almost every
evening there was a cluster of creative people and brilliant talk. No
doubt their conversations contrasted sharply with her lover Dimitri's
more superficial interests. Chanel ended the romance with the Grand
Duke—as she nearly always did—on an amicable note, filling the void
almost at once with the poet Pierre Reverdy, Picasso's closest friend. If
she could not have the forceful painter, at least she could share the pas-
sions of his strong and swarthy alter ego.

Reverdy was solidly built, like the peasant stock he came from, with
a cigarette always dangling from his lips. He was grave and gravelly-

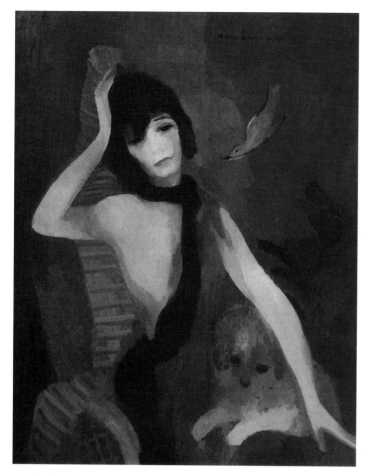

CHANEL COMMISSIONED

*Marie Laurencin, a friend and client,
to paint her portrait, but when she
saw it she refused to pay for it.*

voiced, a moody writer who never gained fame but earned the great respect of his peers. His poems were filled with despair: his phrases of isolation reflected Chanel's darkest fears; his sense of human fragility in a hostile world echoed her own. For all her wealth and independence, for all her supposed success, she could readily identify with his torment. If there was little joy in Reverdy's outlook, Chanel, too, had a somber view. But their love affair, as stormy as his poems, shuddered with anger and revenge.

Though the twosome rarely went out to restaurants or parties, once in a while they joined their colleagues at the home of the Count Étienne de Beaumont. An imaginative aristocrat whose sensibilities attracted the avant-garde, Beaumont offered evenings of original theatrical productions for his artistic friends. On one occasion, Marie Laurencin was invited to do decorations and costumes for an original Cubist ballet; for another, Jean Hugo and Jean Cocteau created a scandal with their homosexual production of *Romeo and Juliet*.

When Cocteau decided to write a modern adaptation of Sophocles' play *Antigone*, he invited Chanel to do the costumes. Why Chanel? he was asked. "Because she is the greatest couturier of our times," he responded. The classical work, on the conflict between the individual and the state, opened in December 1922, and although the sets and masks were by Picasso, it was Chanel who drew the accolades. The critics confirmed that her designs of leather sandals and heavy woolen garments—neutral-colored togas and thick wool jacquard cloaks—had the authentic look of ancient artifacts unearthed and given new life.

Her success with *Antigone* brought more requests. Diaghilev, preparing *Le Train Bleu*, a dance/opera for the Ballets Russes, commissioned Cocteau for the libretto, Darius Milhaud for the music and Chanel, once again, for the costumes. Titled after the luxurious train—decorated with paneled walls and windowed screens of Lalique glass—

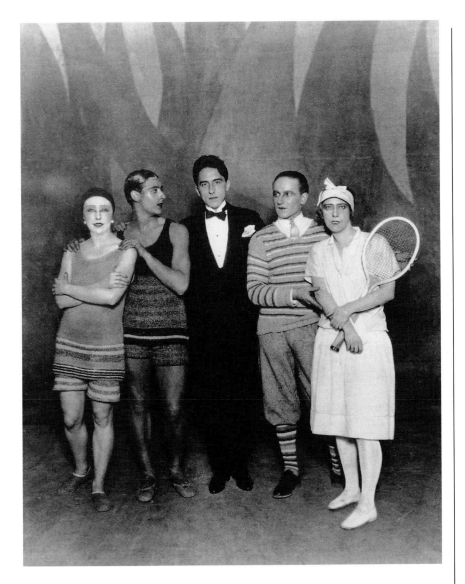

CHANEL'S COSTUMES FOR
Cocteau's Le Train Bleu, *a musical*
pantomime about the rich on
vacation, were inspired by her own
sportswear in the South of France.

that whisked wealthy Parisians to the Riviera, the play was a musical
pantomime of the postwar breed of sporty rich on vacation. For many
years the Riviera had been only a winter resort. Now, as tourists were
beginning to flock there in the summer as well, its popularity spurred
Chanel to open a boutique in Cannes. Designing costumes for the play
was a natural offshoot of her work.

With beach backdrops by Henri Laurens and a theatrical curtain by
Picasso, Chanel created costumes that were close to what she herself al-
ready wore or showed in her collections. Using jersey, her favorite fab-
ric, she made boating outfits, tennis dresses complete with eye shades
and headbands, and golfing ensembles of knickers, striped sweaters and
matching knee-high socks. For both the men and women swimmers in

JEAN COCTEAU FELL INTO
depression and became addicted to
opium after the death of his lover
Raymond Radiguet. Chanel sent
Cocteau to a clinic for treatment.

the play, she designed a two-piece suit with a striped tunic and thigh-length trunk, and gave the female lead a tight-fitting rubber cap to protect her hair in the water. The clothes, the swim cap and the suntans sported by the smart set in the show became de rigueur for anyone going to the beach. Of all the designs for the play, however, it was the fake pearl earrings, made of china covered with wax, that had the greatest effect, propelling Chanel along the path of creating imitation jewelry.

Most important of all was the pragmatism that drove Chanel. Even when conceiving ideas for the theater, she was creating real clothes, not just costumes for the stage. Form followed function, and no matter what she fashioned, she drew her inspiration not from fantasy but from life.

The success of her creations for *Le Train Bleu* bolstered her reputation. In 1923 her daytime look of sweaters and pleated skirts with hemlines just below the knee made fashion news, as did her beaded chemises. Baron de Meyer, arbiter of taste for *Vogue,* called her "a woman of refinement, of instinctive elegance and faultless taste." Her neat, narrow dresses with short, pleated skirts and long, slim tunic tops—in jersey for day and crepe for evening—kept her sales aloft. The following year, however, she created a daring look of cropped pants worn under an unbuttoned skirt, a harbinger of things to come. A few months later, Chanel created a sportswear look for herself that would change the lives of women for the rest of the twentieth century.

Grand Lovers and Great Jewels

THE AFFAIR BEGAN ON A HOLIDAY in Monte Carlo in 1923. The tiny principality of Monaco, a winter retreat for rich Europeans, glistened with the Christmas festivities. Sleek yachts dotted the harbor and lights twinkled in the trees as soigné celebrants, dressed in evening gowns and tails, drank aperitifs at the Café de Paris, dined at the Hôtel de Paris and gambled in the private rooms of the casino, gazing discreetly at the other guests.

For Chanel the resort offered not only a chance to watch society at play—an important element in her work—it served as a respite from some dreary days in Paris. Her friend Cocteau had sunk into despair over the loss of his young lover, Raymond Radiguet, a twenty-year-old poet who had died an untimely death from typhoid. The tragedy had sent Cocteau to his bed, beginning a descent into the world of opium that would last the rest of his life. Friends visiting him in his small apartment would often find the writer's rooms askew, the sickening stench of opium pervading his bed and all around it. Seeing Cocteau's paralysis over Radiguet's

death, Chanel took it upon herself to make arrangements for the young man's funeral, filling the chapel with white flowers, covering the coffin with red roses. Later, disgusted by Cocteau's self-destructiveness, she insisted that he register at a sanitarium where, more than once, she paid for his temporary recovery.

Now she was on a brief vacation with Vera Bates, an engaging Englishwoman who promoted Chanel's clothes and counted among her cronies Winston Churchill, Linda and Cole Porter, and Somerset Maugham. Dining together at the Hôtel de Paris, the two women, striking and smart, were joined by another of Vera's friends, the charming and debonair Hugh Richard Arthur Grosvenor. Nicknamed after his grandfather's winning racehorse Bendor, he was known as the Duke of Westminster to the public, Bendor to his acquaintances and Benny to his intimates. Ruggedly good-looking with a large frame and handsome face, reddish blond hair and intense blue eyes, Westminster oozed elegance. Incredibly rich and infamously sybaritic, he was reported by the gossip columnists to be on the verge of divorce from his second wife: Chanel could not help but be intrigued.

Yet the following day, when Vera Bates told Chanel that the Duke had begged her to bring the fashion designer to dinner on board his yacht, Chanel refused. As engaging as he was, the Duke had earned a reputation as a hedonistic horseman who loved the feel of the chase, no matter whether he was pursuing wild boar or beautiful women. As much as Chanel shared his passion for horses, she did not want to be part of the hunt. Indeed, it may have sounded all too familiar.

But the Grand Duke Dimitri, still a close friend, had joined her that day. He was intrigued with the idea of meeting Westminster, and seeing his legendary boat docked in the harbor, Dimitri urged her to go. With an invitation for him included in the bargain, Chanel reluctantly agreed, and the trio—Chanel, Dimitri and Vera Bates—went off that evening to the *Flying Cloud*. On board the slick, black schooner, among the largest in the world at that time (two hundred feet in length), with four masts and a forty-man crew, the gracious Duke led them on a tour. Passing

THE RICHEST MAN IN *England, the Duke of Westminster was used to having his way, but Chanel refused to give up her independence for him.*

OPPOSITE: **CHANEL** *borrowed and belted the Duke of Westminster's polo coat for a chilly day at the Chester races in 1924.*

CHANEL SERVED AS THE

Duke of Westminster's consort at his residence, Eaton Hall, where it took fifteen hours of driving to see all the grounds.

through what looked like the entry to an old manor house with a heavy wood door, Greek columns, and a carved shell decoration overhead, they walked down a graceful staircase and stepped into his elegant lodgings. The paneled staterooms and luxurious salons were decorated with Queen Anne furnishings and Italian silk fabrics, and the Duke's own lavish bedroom included a canopied bed and hand-blocked curtains. The aura of a country house had been re-created at sea.

Under the stars that evening, the foursome dined while a gypsy orchestra, hired specially for Chanel, serenaded the group. After dinner the fun-loving Duke led them ashore to dance away the rest of the evening at a nightclub. Westminster was trying his best to seduce the French designer, a task he rarely found difficult. With his childlike enthusiasm, natural charm and endless resources, he seemed only to wish and his desires were granted. He was the richest man in England, and wherever he went, whatever he did, he was treated with distinction.

Railroads, boats and cars delayed their departures just for him. At the London train stations, red carpets were laid for him; at the Channel steamers, special gangways were plunked down for him. Loyal servants scurried to do whatever he asked, while high-society ladies scuffled to be at his beck and call. Rarely was he rejected. Spoiled, he wanted Chanel to give him complete attention. She flirted with him in her usual way, batting her eyes, brushing her pearls against her lips, cocking her

CHANEL BORROWED THE
look of Fair Isle sweaters worn in
chilly English country houses, and
made them into snappy cardigans
for women.

CHANEL ENJOYED HUNTING
*boar with Winston Churchill and his
son, Randolph, at Mimizan, the
Duke of Westminster's estate in
France. (c. 1928)*

face close to his. Come away with me now, he begged. She refused to succumb to his wishes. Declaring herself too busy, she even feigned disinterest.

The Duke pursued her with stubborn determination. A good sportsman who was easily entertained, he was also temperamental and restless; at a moment's notice, he rustled his friends from one location to another. Easily bored, he yearned for a woman who would always amuse him. He found in Chanel a witty companion, sexually arousing, self-assured, clever enough to keep him constantly on his toes. But he also demanded a lady who would devote her life to him. At the age of forty, Chanel had worked too hard and too long, had built too big a

business to surrender her freedom to any man, particularly one almost guaranteed to stray.

If women usually chased him, and even tried to trap him, Chanel skirted in the opposite direction. If others were possessive, she insisted on her independence. Her obstinacy and self-sufficiency only made her more attractive to the Duke. For three months, he frantically courted her, but she pretended to ignore his attentions. Instead she worked away in Paris, designing her spring collection and creating costumes for a dance production by the Count de Beaumont involving Cocteau, Picasso and Marie Laurencin.

Westminster set up a postal service just to woo her: while one special courier delivered his messages to her in Paris, another hurried back to England with her answers and a third went off with his replies. He ordered armfuls of orchids and gardenias, grown in his private hothouses, to be flown to her in France, and he lavished her with foods that could not readily be bought. Out-of-season strawberries, peaches, nectarines and freshly caught Scottish salmon arrived at her door in winter. He even sent her a basket of fresh vegetables, and when her servant reached inside, he plucked out a giant emerald. Nevertheless, Chanel, too proud to be seen as another one of Westminster's conquests, declined his affections.

Finally, in March 1924, he arrived in Paris and personally delivered a huge bouquet to her house on the Faubourg Saint-Honoré, bringing along his friend the Prince of Wales to meet her. As the bachelors relaxed in her apartment, the future King of England told Chanel, "Call me David," and she did, flirting with him as readily as she did with his friend. Nonetheless, it was Westminster who finally convinced her of his ardor. With beguiling girlishness, she looked up at him adoringly, respectfully, reverentially; she never corrected him, never overshadowed him. To her, his jokes were funny, his words wise, his actions admirable. Once won over, she knew exactly how to treat him.

From then on, they were constantly at each other's side: at the Opéra, at the races, and even during rehearsals for *Le Train Bleu*, where the golfing clothes she designed for the male lead reflected the style of the Prince of Wales. And in the autumn of 1924 Chanel accompanied

CHANEL HAD A *fascination with men who loved horses. Here, the Duke of Westminster, nicknamed Bendor after a winning racehorse, wears polo gear.*

ONE OF THE MANY
exquisite necklaces given to Chanel by the Duke of Westminster. He loved to surprise her with huge baubles.

Westminster to England, crossing the Channel for his annual party in celebration of the Chester Cup. The two personalities were bound to make the news, and when she appeared with him at the local track, the photographers snapped their pictures. Chanel pulled his polo coat around her and basked in the publicity.

If no other boat she had sailed on was as luxurious as the *Flying Cloud*, no house she had visited was as grand as Eaton Hall. Westminster's official residence, the Gothic castle set in Shakespeare country, sprawled across grounds so vast it took fifteen hours by car to view them all. Surrounded by Italianate terraces, ornamental lakes and allées of trees, the Great House overlooked training courses for horses, model agricultural farms, fields of flowers, and forests of the Duke's favorite rhododendrons.

Indoors, the acres of walls were covered with paintings by Rubens and Raphael, Rembrandt and Hals, Velázquez and Goya; in the hallways, statues of knights stood in armored silence as a retinue of liveried servants rushed about. The household was on twenty-four-hour alert, in case any of the English royal family, related by birth to the Duke, came to visit. And no matter where in the world Westminster was, at Eaton Hall his staff was prepared for his arrival. The butlers and footmen, parlormaids and chambermaids, cooks and kitchen staff, landscapers and gardeners were always on hand. At all times, the fireplaces glowed with burning embers, the beds in the guest rooms were ready to be turned down, dinner was available to be served. The seventeen Rolls-Royces (loaned to the British Army during the First World War) parked in Eaton Hall's garages were always in perfect condition, their tanks filled with petrol, engines warm and ready to go.

With fifty-four bedrooms, Eaton Hall could well accommodate dozens of guests for the racing festivities. During the day, visitors were shuttled back and forth by a fleet of chauffeur-driven limousines. In the evenings, after dining on lavish meals that featured champagne, caviar, snails and such exotics as plover eggs, the men enjoyed brandy and cigars, the women powdered their noses, and all gathered in the ballroom, either to be entertained by hired performers or to dance while an orchestra played. Visiting Eaton Hall wasn't difficult for Chanel, and soon she was more than just a privileged guest. She was Westminster's consort, cohost of his huge estate.

In London, where he lived at Bourdon House off Berkeley Square, his holdings included large portions of Mayfair and Belgravia, with the property rights to Grosvenor House, the Connaught Hotel, Mayfair House, Claridge's, Victoria Coach Station, Park Lane and Oxford Street. Each time they traveled, Chanel discovered another of his homes: in Ireland; on the Dalmatian coast; in the Carpathian mountains;

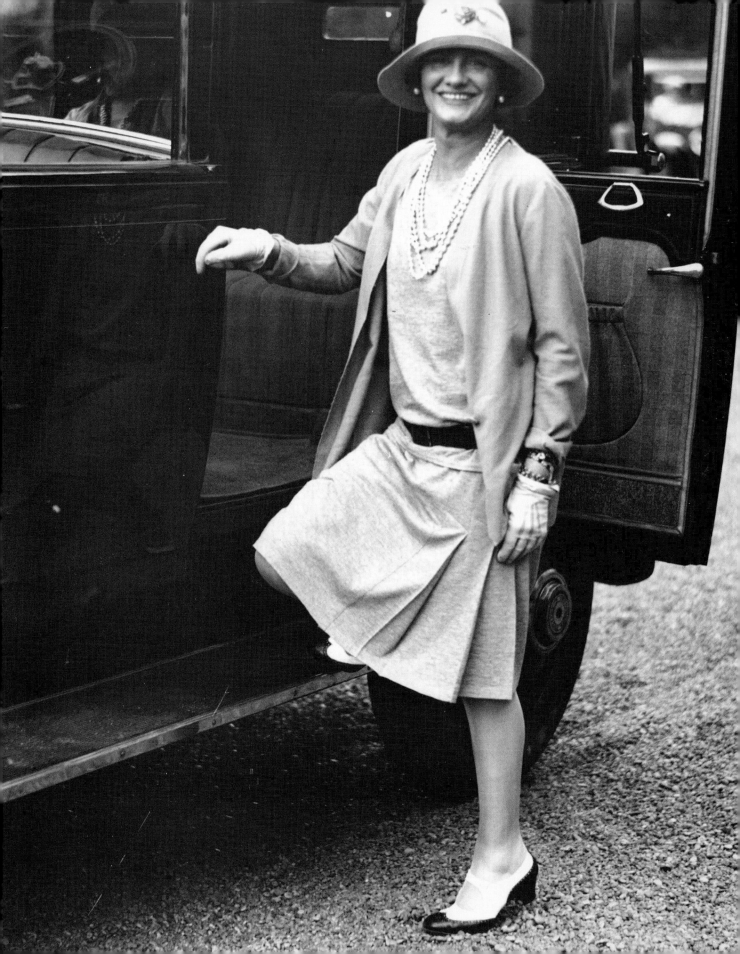

in Norway. In Scotland, at Stack Lodge, his estate in Lairg, not only was the staff always on hand, the grouse were always ready for the chase, and the salmon stocked to be caught. In France he owned a chateau near Rouen in Normandy and a hunting lodge called Mimizan, so isolated and deep in the pine woods between Bordeaux and Biarritz that it took special cars to reach it.

The wealth was astounding. "I've known luxury such as one will never know again," Chanel told a friend. Everything was at his disposal: she did not dare to claim so much as a migraine headache, because as soon as she uttered the words, no matter where they were, Westminster would have the most famous doctors from Harley Street at her bedside.

As his hostess, she entertained great numbers of guests, including Cunards, Marlboroughs and Lonsdales; and although she stubbornly refused to speak English even while secretly studying it, she was accepted among the highest-born aristocrats and wealthy industrialists as one of their own. When Winston Churchill, Bendor's closest friend since the Boer War, came to Mimizan, as he frequently did for a weekend hunt, he dashed off a note to his wife: "The famous Coco turned up and I took a gt fancy to her—A most capable & agreeable woman—much the strongest personality Benny has yet been up against. She hunted vigorously all day, motored to Paris after dinner, & is today engaged in passing & improving dresses on endless streams of mannequins."

The Duke reaped enormous pleasure from providing her with gifts, and delighted in surprising her with necklaces, earrings, bracelets and rings. Not only were her arms, neck and ears decorated with his jewels, her apartment was filled with his generous offerings. Even today, chased enamel boxes lined with gold and embellished with his family crest rest on the lacquered tables in her private suite on the Rue Cambon.

Whether sailing the Mediterranean on the *Flying Cloud*, crossing rougher seas on the *Cutty Sark* (a former destroyer with a crew of 180) or serving as hostess at the Duke's houses, Chanel acted as his equal. In winter she joined him on his estates and hunted three times a week for fox and boar. When the weather was mild, they played tennis and golf together. She learned to fly-fish for salmon—hesitantly at first, then growing to love it—and spent ten hours a day casting in the river. In one period of two months she landed a record fifty salmon. "I've never

CHANEL IS WEARING HER *classic jersey suit with a cardigan jacket, low-belted pullover top and pleated skirt. Her shoes are two-tone pumps, and she gives the outfit her own special look with ropes of pearls and a brimmed cloche pinned with a smart brooch.*

LEFT: **CHANEL'S BEADED**
fringed evening dress was typical of
her Jazz Age looks.

RIGHT: **CHANEL'S FLAPPER**
girl wears her pleated skirt at her
knees, has an embroidered white coat
to go with her white crepe dress, and
wears a soft cloche on her head.

done anything by halves," she explained. She had a singular drive to succeed, and her standards measured success at only the highest levels. Whether as courtesan or consort, sportswoman or entrepreneur, she aimed for the top and accepted nothing less of herself.

She was a role model for other women. When two American authors published a book about Paris, they advised their unmarried readers to rush to the Rue Cambon: "If a woman wants to catch a husband, she goes to Chanel who knows exactly what men like. Chanel models have IT, doubtless because Chanel herself has plenty of the same." In August 1924, when the papers reported that Westminster's wife was suing him for divorce, there were photos of Chanel with the Duke. Women's eyes

widened at the sight of the designer with one of the world's most desirable men, and they tried to imagine themselves in the same frame. If they could dress like she did, perhaps they could live like she did.

Despite the lavish attention Chanel paid to the Duke, she never neglected her business. When she had to part from him to design her collection in Paris one season, and he balked unhappily, they set up workrooms for her on his estate.

By 1925 Chanel perfume—now backed by the entrepreneur Pierre Wertheimer—was being distributed on a worldwide scale, and Chanel couture was being sold on the Rue Cambon at a snappy pace. Even copies were in demand. Indeed, few things pleased the designer as

WHEN CHANEL APPEARED IN
Venice wearing trousers, it started the
trend of pants. Here she is with Misia
Sert (center) on the Lido.

much as seeing less expensive versions of her clothes. The more they were imitated, the more successful she felt. She had confidence in her deceptively simple styles, knowing that even if her clothes seemed easy to forge, the cut, the details, the seamlessness of her work could never be matched. Nor did her clients doubt that, despite the lower-priced clones, nothing equaled the comfort or the cachet of an authentic Chanel.

As the Duke's world seeped into hers, her collections reflected their love affair. His English polo coat, which she had borrowed and belted on that chilly day at the Chester races, became a chic look for ladies all over the world. The British predilection for tweeds, it is true, had been shown in crisp clothing by Redfern, but Chanel softened the Scottish fabrics and gave them her own style. At a textile factory provided by Westminster, she manufactured her own wools, then produced them in suits and coats and, using reverse snob appeal, lined them with fur. She took the Fair Isle

OPPOSITE: **CHANEL (LEFT)**
liked to visit Venice with her close
friend Misia Sert (center). Here they
sit on the beach on the Lido.

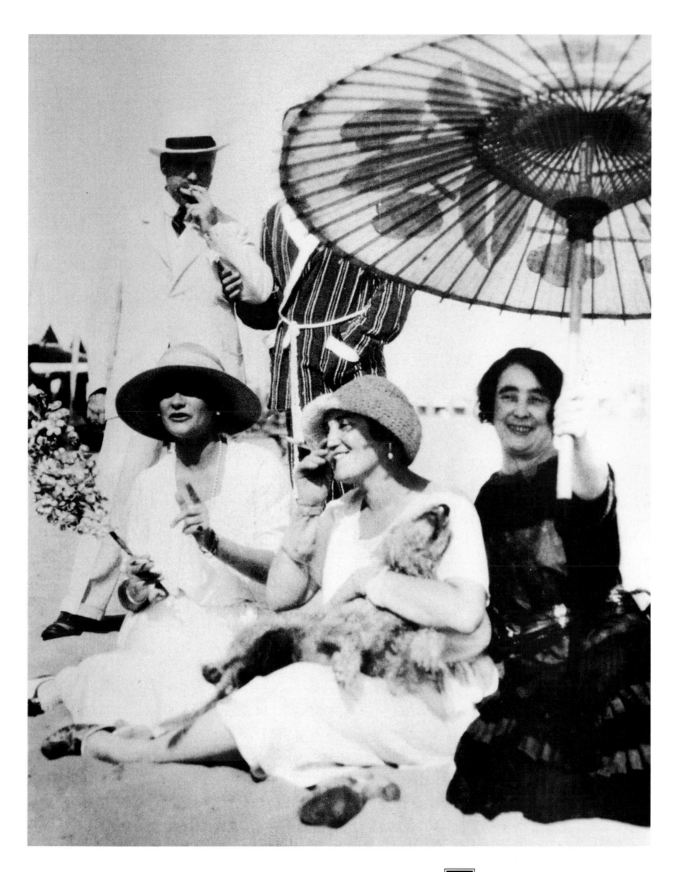

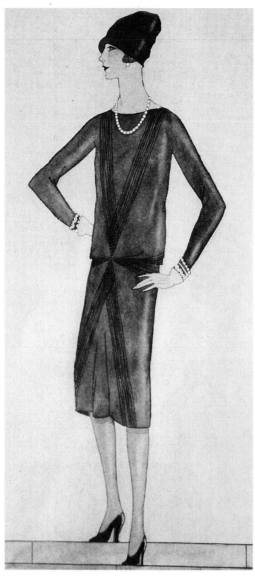

sweaters worn by so many Scotsmen and turned them into cardigans and pullovers for herself. Nothing was sacred.

Westminster's blazers and cuff-linked shirts also turned up in her collections, as did his butlers' pinstriped vests and his chambermaids' uniforms. His boat crew's peacoats, emblazoned with brass buttons, strutted down her runway, and his yachting caps, given as gifts to the guests aboard his yacht, were pinched into smart berets, set off with large jeweled pins. His sailors' outfits were rendered into striped sweaters worn under slim jackets and matching pleated skirts; fabricated in jersey, they became one of the early versions of her now eponymous suit.

Wherever she went, she plucked ideas for her workshop. She had a clever knack for adaptation, and because she knew what worked for her, she knew what would work for other women. She recognized that male styles offered more than just ease; they afforded a sense of power. She knew, too, that a woman dressed in men's clothes felt either emphatically feminine, like a fragile doll wrapped in a masculine aura, or erotically androgynous. And so, when Chanel appropriated sailor's trousers worn by Westminster's crew, she not only liberated women from a constricted style of dress; she freed their libidos, allowing them to enjoy their sexuality.

Insisting there was no other way to comfortably climb on and off a boat, Chanel designed a pair of flared pants for herself, similar to the ankle-length bell-bottoms worn by Westminster's sailors. Little by little she expanded on the notion of trousers, showing up at the beach in white silk pants, black jersey top and ropes of pearls, or in the evening decked out in silk pajamas. Though other designers such as Molyneux and Lanvin had offered similar looks in their collections, when pictures appeared in the fashion magazines showing Chanel in slacks, the buzz was on. She was her own best model and her own best publicist. No one else wore pants with such panache. Thanks to her, the trend of trousers began, changing the lives of women, causing them to rethink their way of dress for the rest of the century.

As readily as she understood the appeal of menswear, she acknowledged the need for a woman to feel utterly feminine. At almost the same time that she started wearing slacks, she introduced gossamer evening

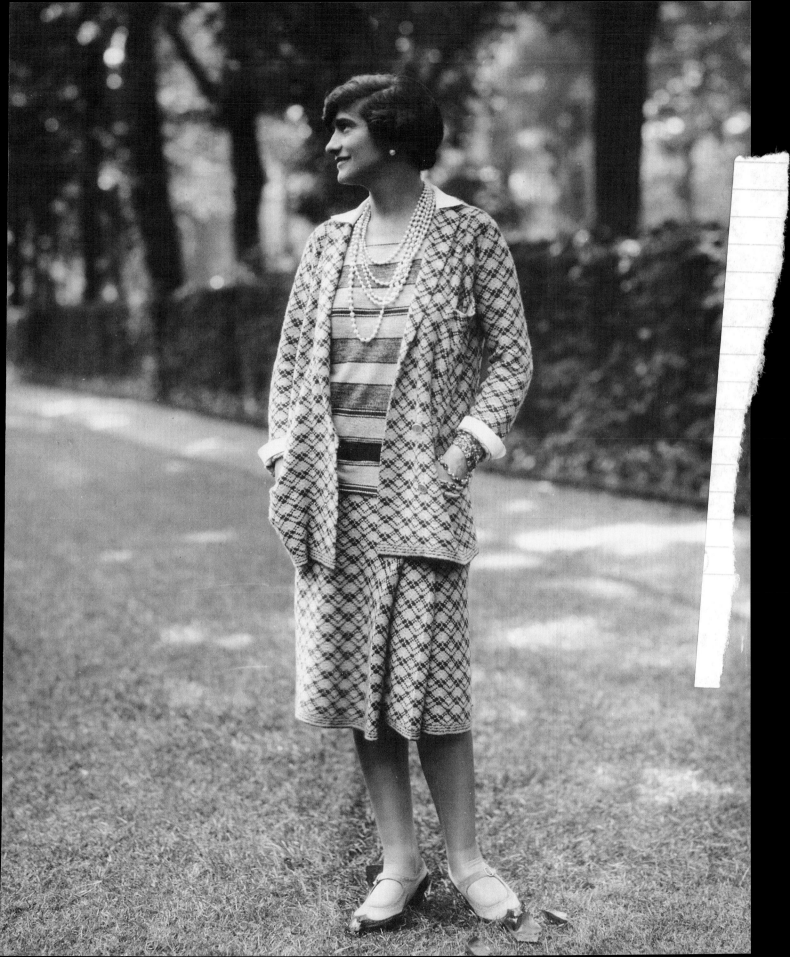

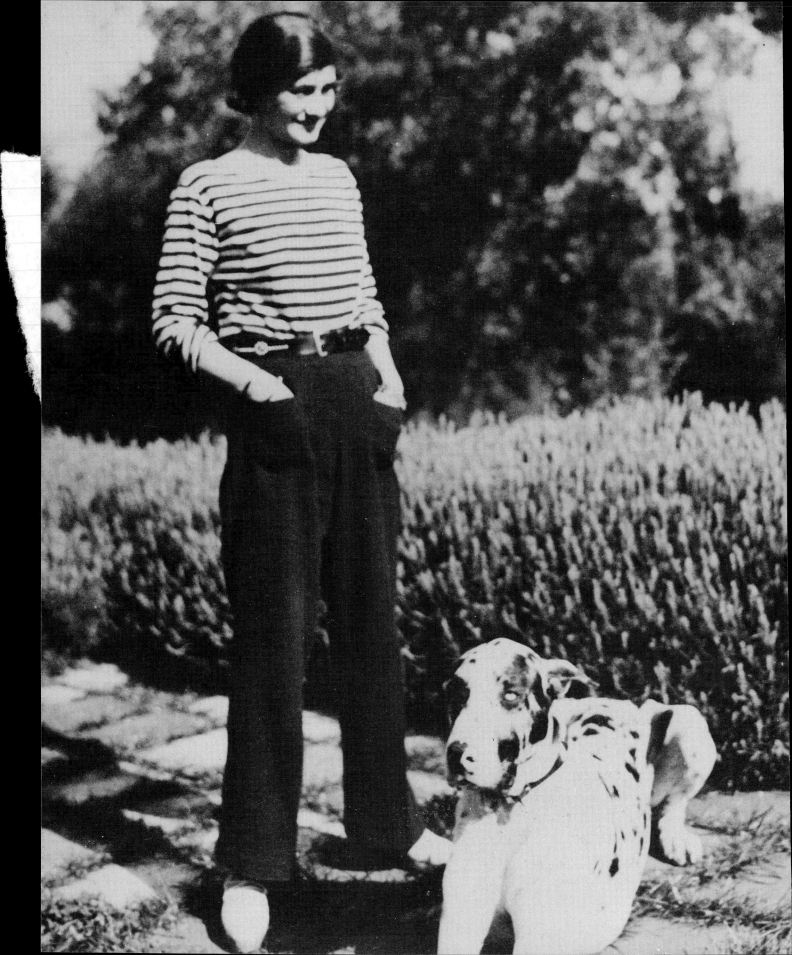

dresses made of delicate black lace. The gowns, sometimes embroidered with metallic threads, enhanced a woman's flirtatiousness and seemed to turn the most jaded sophisticate into a fragile ingenue.

But nothing expressed Chanel's adroitness better than her creation of the Little Black Dress. Between the wars, in an era flush with opulence, it was the essence of insouciance, a backlash against all the extravagance—the bright colors, explosive prints, the prevalence of gold and silver, fringes, feathers, beads and heavy embroideries—that dominated the Jazz Age scene. The long-sleeved black chemise, done for day in wool or chenille, and for evening in satin, crepe or velvet, shook up the fashion world. American *Vogue* sensed its importance at once and called the easy black dress the "Ford" of fashion. Customers caught on quickly. Stripped of all excess, it made the woman who wore it feel elegant no matter where she went. And although Chanel had created it as an expression of austerity, she soon turned it into a foil for adornment. The Little Black Dress became the symbol of chic, a look that has lasted for almost seventy-five years. Despite its simplicity, however, it took a daring woman to design it and, oddly enough, an American audience to accept it. For all of Chanel's French characteristics, her clothes had a decidedly American appeal. As opposed to the complicated look of other couturiers favored by some French clients, her minimalist approach mirrored the easy dressing that women such as the author Anita Loos and the American editor of *Harper's Bazaar*, Carmel Snow, wanted and wore.

Chanel's place in the design world was confirmed at the Exposition des Arts Décoratifs held in 1925. Her slim, androgynous look, stripped of all superfluousness, defined the contemporary woman. With her inclusion in the exhibition popularly known as Art Deco, she could indeed claim herself the essence of modernity. That same year, Diaghilev called on her to work with the Cubist artist Georges Braque on costumes for the ballet *Zéphire et Flore*, and George Bernard Shaw called her "the fashion wonder of the world," putting her on a level with the great scientist Marie Curie.

Yet as modern as Chanel wanted to be, she relied in an old-fashioned way on men. Independent and self-sufficient in business to the point of being brusque, she constantly needed male reassurance to sustain her in her private life. Westminster provided her with the strength and calmness she craved. She called him her "shoulder to lean on," a tree she

CHANEL BORROWED THE *look of the striped navy shirt and casual pants from the crew of the Duke of Westminster's yacht, the* Flying Cloud.

could prop herself against; he was the only other man she compared to Boy Capel. If she hadn't met the Duke, she told a friend, she would have gone crazy from "too much emotion, too much excitement."

The only weakness in their relationship, it seemed, was that Westminster desperately wanted a male heir. If he did not have a son to continue his line and inherit his wealth, his fortune would go to a cousin. Yet despite surgery and special exercises, Chanel could not conceive. Tension mounted as she failed to provide the child he desired. They remained together nonetheless, and in 1928, when she built a house in Roquebrune on the Riviera, she designed a personal suite for him.

But Westminster proved to be worthy of his earlier reputation. Predictably, his eye wandered and his sexual peccadilloes caused her much embarrassment. Pretty young women appeared at his side or arrived on his yacht in her presence. The more humiliated she felt, the more their relationship weakened. To make amends for his behavior, Westminster surprised her with expensive gifts, but the trinkets weren't worth the price of putting up with his betrayals. After an argument over one attractive guest on board the *Flying Cloud*, the Duke tried to repair the damage by presenting Chanel with a stunning jewel. Reacting with vengeance, she tossed the costly emerald overboard.

The friction inflamed their volatile tempers. If he felt disappointment over her inability to produce an heir, she undoubtedly felt disappointment in herself. Despite her talent for seduction, she could not complete her female role. His need to possess clashed with her fierce desire to remain free. He suffered from anomie and impatience; she demanded time and space for her work. And although she enjoyed the company of his friends, he could not tolerate hers. Artists and writers made him uncomfortable, and he felt bored if not mystified by their enigmatic talk. When Chanel visited Cocteau in his rooms or dined out with Diaghilev and his clique, Westminster rarely went along. As for Misia Sert, Chanel's closest female friend, the Duke found her incomprehensible. Her catty tongue, her disinterest in sports, her complaints of ennui at Westminster's fishing estate in Scotland did little to strengthen the bonds between Misia and the Duke. Nevertheless, she was the only woman to whom Chanel seemed to feel a sense of debt, and when Misia was cast aside by José-Maria for a younger woman, the Duke agreed to have her join them on the *Flying Cloud*.

In August, the trio set sail in the Adriatic, but an urgent telegram

caused them to stop almost at once in Venice. The magical city had always been a source of inspiration for Chanel, who had often toured it with Misia, visiting the art galleries, studying the riches of St. Mark's: the stained glass windows and the mosaics, the crosses, the enamels, the articles of filigreed gold. It was in Venice, too, on the beach at the Lido in 1929, that Chanel made fashion news when she appeared in pajamas. And it was there, as well, that the hot sand burned her bare feet, giving her the idea to tie two straps around a sheet of cork and cut it into sandals, a style that became popular around the world.

But this time the stopover in Venice took on a more somber tone. Their friend Diaghilev, suffering from a long siege of diabetes, was laid up in a hotel on the Lido. Always theatrical, he was dressed in his dinner jacket, attended by his lover, Serge Lifar, and his secretary, Boris Kochno, when the women arrived. Just a few months earlier, at the end of the ballet season, Chanel had saluted Diaghilev at a party she hosted for him on the Faubourg Saint-Honoré, a garden celebration with a jazz band and mounds of caviar. The small group in the hotel room shared memories, too, of the evening preceding the garden party when Diaghilev's last ballet, *The Prodigal Son*, had been produced in Paris to standing ovations. After the performance, at the Capucines restaurant, Misia and Chanel had sat on either side of Lifar, as the teary-eyed Diaghilev thanked the dancer for his choreographic achievement. "There is nothing more I can teach you," Diaghilev told his student and lover.

Now the words seemed prophetic as Diaghilev lay propped up in bed, gravely ill. Seeing his condition, Misia decided to stay, but Chanel went off again with Westminster. Two days later, feeling that something was wrong, she begged the Duke to turn the boat around. By the

CHANEL BEGAN HER CAREER *making hats and continued to design them with all her collections. In 1929 the straw cloche gave pizzazz to the jacquard outfit.*

CHANEL USED JERSEY IN *everything from hats to suits. Here she pins a large brooch on her jersey beret and trims the jersey jacket with a white collar.*

time they returned to Venice, Diaghilev was dead. Funeral arrangements had to be made, but the Russian spendthrift had left no money, and Misia, though less than rich, was ready to sell her diamond necklace to cover the expenses. Instead, Chanel generously took care of the costs herself. After services at an Orthodox church, the two women, dressed in white, boarded a black gondola and, bidding a final good-bye to their friend, buried Diaghilev on the island of San Michele.

Chanel returned to Westminster's yacht, but the rest of the cruise was rancorous. The couple bickered constantly, bringing their anger with them to La Pausa, Chanel's new summer retreat in the South of France. Friends staying at the villa could hardly avoid hearing them argue, even in their private wing, and although they attempted to patch it up, the love affair was clearly over. Chanel returned briefly to the arms of Pierre Reverdy, and by Christmas-time Bendor had met Loelia Posonby, a woman half his age, to whom he announced his engagement. Before his marriage to the well-bred daughter of the protocol chief to the king, he brought her to Paris to meet Chanel. The designer, dressed in a smart blue suit and white blouse, jewels at her ears, her neck and her wrists, offered her young rival a perch on a low stool while she sat on the couch and looked her over. The conversation was awkward, and the hostess hardly made it easier, trying her best to intimidate, sharply dismissing Loelia's suggestion that a necklace the younger woman had been given as a gift could possibly have been made by Chanel. But the bride-to-be was not cowed, and the future Duchess of Westminster soon became a client of Chanel's. The Duke remained a friend and supporter, and the following year he loaned Chanel a house in London to use for her fragrance business. If wedding bells were out for Chanel, her whirlwind career was still on.

Costume Dazzle

THE SIX-YEAR ROMANCE with Westminster left Chanel with a wealth of jewels. The Duke's splendid favors included Indian bibs of rare diamonds and emeralds, matching bracelets of rubies, emeralds and sapphires, brilliant solitaires, strands of diamonds and emeralds, and ropes of pearls. Although her favorites, by far, were the pearls, which she piled on everything from beach pajamas to hacking jackets, Chanel considered many of Westminster's presents too provocative to wear. "It is disgusting to wander around loaded down with millions around the neck just because one happens to be rich," she declared. Instead she kept most of his gifts, alongside those from Dimitri, in the vault; others she removed from their settings and re-designed.

The glittering coffers conjured up visions for Chanel: instead of the ostentatious gems used only for evenings, she began creating imitations and wore them mixed with the real ones for day. Shrugging off the obsequiousness of the rich, she felt style was more meaningful than

87

LEFT: **THE GREAT JEWELS**
from her lover inspired Chanel to create costume jewelry that could be worn for day. This elegant necklace combines two rows of evenly sized pearls with two rows of round rhinestones and a smaller strand of graduated pearls.

RIGHT: **CLUSTERS OF**
sapphire-blue glass and turquoise studs are attached by gold metallic chains in this necklace by Gripoix for Chanel.

status. Jewelry in and of itself did not impart prestige; it was only important if it was worn with panache.

Turning to the Count de Beaumont, the aristocrat who had once excluded her from his social set, she called on him now to help her design a collection of real and imitation jewels. He was acknowledged for his exquisite taste and style, and was known for, among other things, his gorgeous eighteenth-century house, his brilliant balls, and the baubles he personally created and gave to friends. Never had he held a paying job, but persuaded by Chanel to work for her, he established an atelier. The favors of her past and present lovers became the inspiration for many of the pieces they created together. Borrowing from the Grand Duke Dimitri's imperial gems—Byzantine looks, cabochon stones and Maltese crosses—they made ropes of gold chains studded with glass stones and colorful eight-pointed crosses. Strands of priceless pearls inspired long, affordable simulated ropes. The real was mixed with the mock: beautifully cut diamonds were combined with colored glass; semiprecious stones united with pearls. And in Chanel's decidedly con-

trary way, she wore earrings made of fake pearls, but instead of the usual set of black or white, she put on one black earring and one white and pronounced them a pair.

The Chanel style, which had once meant jersey dresses and uncluttered designs, took another twist with the success of her costume ornaments. Her amused and self-assured approach changed the way that women thought about jewelry and about themselves. Thumbing her nose at tradition, she turned the snobbish realm of jewelry into the fantasy world of the fake. If fashion had been determined by fancy clothes and expensive gems, she made it chic to look poor, ennobling to wear paste. Her inverse snob appeal meant that her mock jewels had more cachet than the genuine. Her costume pieces were the preferred adornment, and as fast as the stock market rose, the rich piled on her imitation pieces. The flush of celebration went hand in hand with the flash of *faux bijoux*.

In the fall of 1929, the stock market crashed. Most American women could no longer flock to Paris to buy their clothes, private dressmakers

LEFT: **THE ENAMEL CUFF IN** *black or white studded with glass stones became an important look in Chanel jewelry. Although often designed with a Maltese cross, this cuff has a floral composition.*

RIGHT: **AN INDIAN BIB OF** *rare rubies and emeralds given to Chanel by the Duke of Westminster inspired this necklace of red beehives, green glass balls, green leaves and pearls.*

LEFT: **THE GRAND DUKE**
Dimitri's imperial Russian influence shows in this costume jewelry necklace of multiple strands of pearls set off with a rhinestone star medallion.

RIGHT: **CHANEL USED**
rhinestones set in a base metal for this arrow that pierces the heart. She made it chic to wear costume jewelry.

could no longer cash in by sewing up copies of Chanel clothes, and the couturiers were no longer as busy as before. But Chanel's success continued as customers from India, Asia, South America and the Middle East sought out her showroom. Her classic styles—such as an unlined, navy-blue jersey suit, with its casual V-neck jacket and four patch pockets, and its A-line, selvage-edged skirt—were so elegant yet unassuming that only their wearers knew how expensive they were.

Yet, while once-rich Americans wrung their hands over fortunes lost, in Paris still-wealthy socialites whirled through a frenzy of parties. "The June season of 1930 will be remembered as the greatest fancy-dress-ball season of all years," reported Janet Flanner in *The New Yorker.* Rothschilds and Guinnesses, papal descendants and extravagant aristocrats outdid one another with capricious subjects and spectacular settings, from traditional formal scenes to a Louis XV shepherd theme (complete with a fox) to a silver soiree in which an entire garden, including the limbs of the trees, was wrapped in silver foil. Never a small

matter—thanks to the ingenuity of the Count de Beaumont, the first to marry noble status with creative flair—the decorations were done by artists such as Picasso or Christian Bérard; the choreography by Serge Lifar, Boris Kochno or Nijinsky; and the costumes by the finest couturiers. The lighthearted balls had become major theatrical events.

Chanel not only attended the parties as a guest; she was asked by some of society's biggest names to create their fantasy gowns. The commissions provided abundant work for the 2400 people now employed by her and housed in the five buildings she owned on the Rue Cambon. Her seamstresses stitched away, but the fittings for clothes were more complicated than usual: invitations to one of the most noted balls, hosted by Elsa Maxwell and Daisy Fellowes, requested guests to come disguised as someone that everyone knew or would recognize. The surprise lay not just in the clothes but in the cross-dressing: women came dressed as men, and men masqueraded as women. "Chanel did a land office business," wrote Flanner, "cutting and fitting gowns for

LEFT: **THESE HALF-FLOWER** *earrings were often worn by Chanel. They have a pearl center surrounded by rhinestones and gold metal leaves.*

RIGHT: **THIS FLIGHTY** *flamingo brooch is made of rhinestone and gold with a red glass eye. The name* CHANEL *is stamped in script.*

CHANEL'S HOLLYWOOD VISIT
*inspired this colorful Verdura brooch
of a man waving from his perch in a
palm tree.*

OPPOSITE: **VARIOUS**
*influences can be see in the jewelry
worn here by Chanel. The dazzling
necklace has the look of a Russian
medal of honor; the bracelets were
inspired by the Byzantine combination
of enamel and gold studded with
colored stones.*

young men about town who appeared as
some of the best-known women."

Chanel's own fetes had acquired a reputation for being nothing short of fabulous. Her soiree the following year made news not only in Paris but in the *New York Times.* "Mlle. Chanel's parties are known for their superb decorations and profusion of artistic talent," said the paper of record. To celebrate the races, which she still liked to attend, during a summer week of steeplechase at Auteuil followed by the Grand Prix at Longchamp, Chanel hosted a gala in her Faubourg Saint-Honoré garden. Under a tent of gold tissue illuminated by hidden lights, several orchestras played and performers from the stylish Ambassadeurs nightclub entertained. Among the guests were Gloria Swanson, Lady Mendl, Paul Morand, the Reginald Fellowes, the Grand Duke Dimitri and his American wife, and the Baron de Rothschild and his wife, who amused themselves dancing until the early hours of the morning, dining on an elaborate array of foods, admiring the floral panorama of white hydrangeas, lilacs and lilies placed at the end of the pavilion. And of course, Chanel's white dress was designed to complement the surroundings.

Costumery consumed her interests. In Monaco that year, Dimitri introduced her to Samuel Goldwyn, an American moviemaker, who offered her the chance to do costumes for his films. To him, Chanel epitomized elegance, and her clothes held the promise of romance that every female moviegoer dreamed of. If she would come to Hollywood just twice a year to dress his stars and design the costumes for his studio, Goldwyn said, he would pay her a million dollars. She was America's favorite French designer, he suggested, and he was right.

Thanks to her clothes and her perfume, now the bestselling fragrance in the world, her photograph was frequently seen in periodicals, her name and face were well known, her reputation well established.

The American press had acclaimed her early on: from the opening of
her first boutiques in Deauville and Biarritz, to the creation of her little
black "Ford," *Vogue* and *Harper's Bazaar* had consistently featured her
relaxed, uncluttered clothes. Their readers understood her insouciance,

SAMUEL GOLDWYN OFFERED
Chanel a million dollars to design costumes for him. One of the movies she did was The Greeks Had a Name for Them, *starring Ina Claire (left). The actress was a regular client of Chanel's.*

and they identified with her defiant spirit. Her self-confidence gave them confidence; her freedom freed them. While Europeans may have preferred the complicated fashions of some of the other French couturiers, American women appreciated her fresh, young style. Flattered by Goldwyn and driven by her insatiable desire for wealth, she could not resist. But this time her practical nature foundered in the current of Hollywood fantasy.

In 1931, accompanied by Misia Sert and a phalanx of models, seamstresses and helpers, Chanel boarded the steamship *Europa* and sailed to New York, where scores of reporters waited for interviews. Ten days later, joined by the press, the group embarked on a specially painted white train, hired by Goldwyn to speed her to Los Angeles. The arrival was heralded in the papers.

But the designer's future in films drew mixed predictions from the gossip pundits. While most applauded Goldwyn for creating a fashion

coup, others anticipated trouble from clashing egos. When Greta Garbo welcomed Chanel, one paper headlined the event as THE MEETING OF TWO QUEENS. Some reporters predicted that the brilliant stars of Hollywood would resist being outshone by a prima donna from Paris. They were right. Most of the famous females received her with more than a dash of skepticism.

Nothing about Chanel smacked of the flamboyance surrounding them. If anything, she was known for innocent looks and understated style; a sense of youthful flirtation, not flagrant sexiness, gave her clothes their appeal. Yet that was hardly the fabric of film legends. Nevertheless, the studio moguls ruled, and when Goldwyn ordered Gloria Swanson, the star of *Tonight or Never*, to appear for fittings with Chanel, she had little choice but to do as she was told.

Seen in the movie in a narrow jersey suit turned back at the wrists, worn over a blouse with white collar and cuffs, Swanson was dressed in an outfit almost identical to one that Chanel liked to wear. The designer had created a wardrobe for the film star that bore a strong resemblance to her own. But clothing that looked elegant in ordinary life seemed indifferent on the screen. When both the film and the costumes flopped, Chanel's reputation in Hollywood moved down a notch.

The theatrical star Ina Claire, who wore Chanel clothes on the stage, had been hired to do the film *The Greeks Had a Name for Them*, and Chanel was asked to design the costumes. Although the movie received favorable reviews in the press, the fashions drew almost no comment. As the word spread that Chanel clothes would do little to enhance an actress's image, antagonism grew. With some minor films to her credit, and a million dollars in her bank account, Chanel ended her Hollywood career. Her style was of a quality too elusive for the industry of illusion. But the publicity ploy, which had been less than successful for Goldwyn, did little to harm Chanel. She was a shrewd businesswoman; her name had been beamed before the public and, in New York alone, her clothes were being sold at B. Altman, Henri Bendel, Bergdorf Goodman, Bloomingdale's, Lord & Taylor, Hattie Carnegie, Frances Clyne, Franklin Simon and Saks Fifth Avenue.

Soon after she abandoned Hollywood, she was introduced by Linda Porter, wife of the composer Cole Porter, to a clever bon vivant, the Sicilian duke Fulco di Verdura. Although he was cultured, cosmopolitan and educated in the arts, Verdura was inexperienced in fashion when

IN *TONIGHT OR NEVER*
Gloria Swanson wore a tailored suit with a white collar and cuffs, a smart Chanel style but not glamorous enough for Hollywood stars.

Chanel hired him to design fabrics. She soon noted his interest in jewels and gave him the opportunity to interpret some of her ideas.

With her passion for early bibelots and his love of historical objects, they traveled to see the great Renaissance and Byzantine treasures in the Schatzkammer Museum in Munich and the Charlemagne collections in Dresden. In Paris there was the Louvre with its European Renaissance and ancient Middle Eastern collections. And always available were her own precious jewels. Back in his workrooms, Verdura pressed mosaics of large, colored glass into barbaric gold brooches, and set crosses of semiprecious stones into broad enameled bangles. Her favorite object, the Maltese cross, familiar to him because of his family's Mediterranean background, became a recurring theme. The colored cruciforms and jewel-encrusted, lacquered cuffs became a signature Chanel look.

CHANEL'S OWN JERSEY SUIT
with white collar and turned-back
cuffs was the inspiration for the
costume she did for Gloria Swanson.

Inspired by her cache of rare gems, Verdura worked with gold, lacquer and brilliant stones to fashion flowers, faces and fish into fanciful pins. Other novel ideas emerged: from Hollywood came palm trees and monkeys, from London came a lamplight pin stamped TRAFALGAR; from her Russian embroideries came intricate earrings and necklaces, from her garden came floral sprays and bouquets. Although Verdura's work appeared in her collections until 1934 (when he moved to New York), Chanel also employed the talents of the theatrical designer Christian (Bébé) Bérard, and of the famous jewelers Gripoix, who made simulated pearls, and De Gorse, who worked in gold. Chanel herself often sat on her couch in her drawing room on the Rue Cambon showing friends her stash of loose gems. With a pile of jewels sprayed across the Oriental coffee table, she played with the colored stones and balls of putty, setting and resetting, shaping and reshaping, creating pieces as

CHANEL'S BERET, PINNED
with a brooch, was inspired by the
crew's caps on the Duke of
Westminster's yacht. She is wearing
her famous pearls and a cuff with the
Maltese cross, and sitting in front of
one of her famous Coromandel
screens.

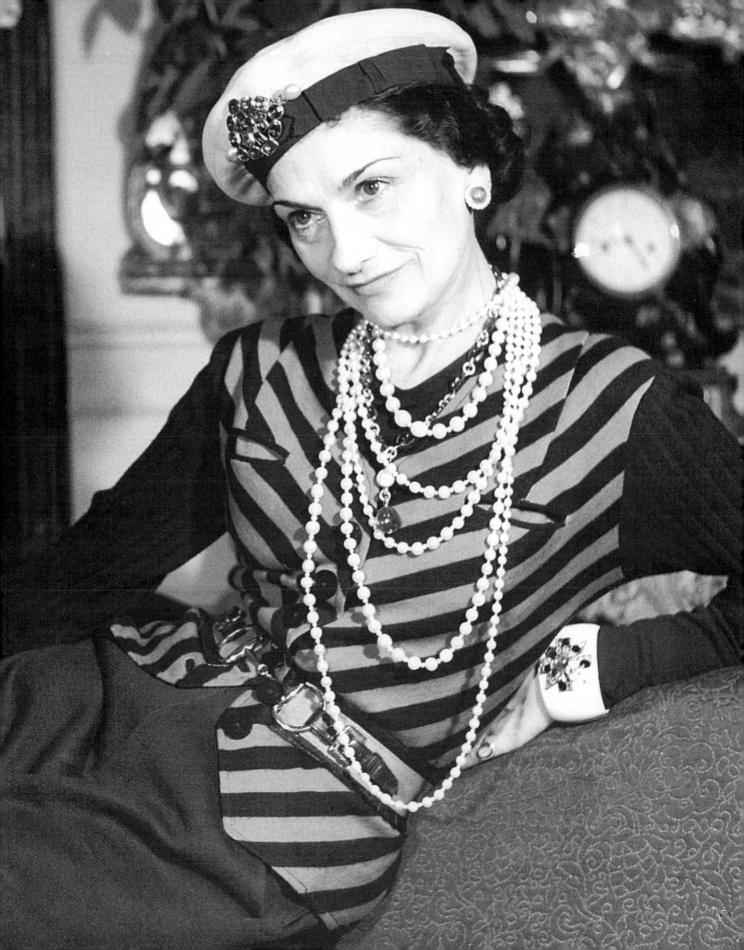

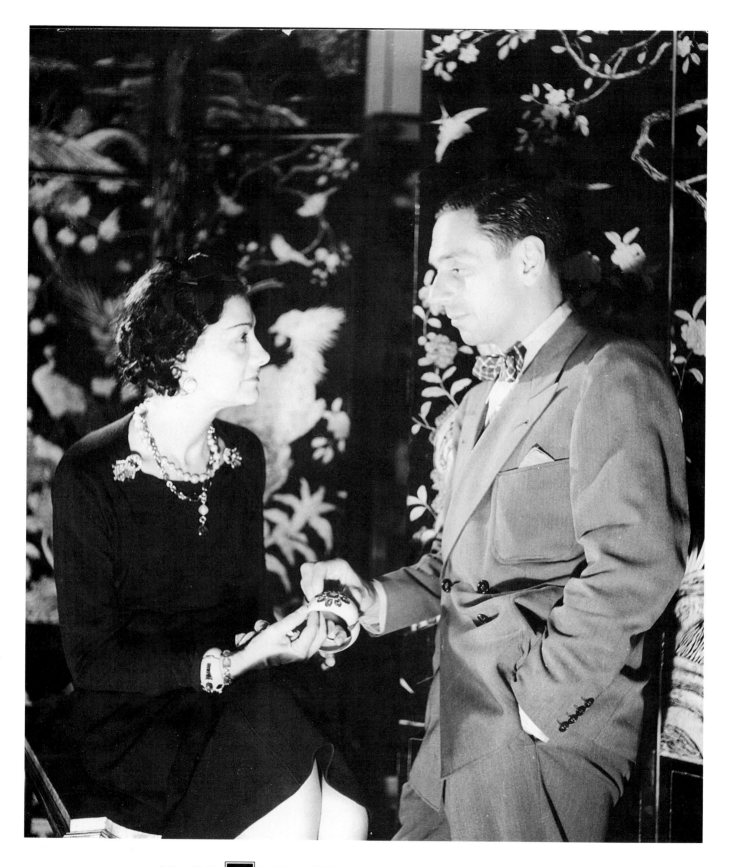

CHANEL USED HER FAVORITE
*fabric, jersey, for this ice skating
costume she wore in Switzerland.*

OPPOSITE: **THE COUNT**
*Fulco Di Verdura was a cultivated
man who created jewelry for Chanel.
His most famous contribution was the
enamel cuff studded with a Maltese
cross.*

she chatted. Rare was the moment she wasn't working, absorbing impressions, fashioning ideas.

But she was always stimulated by surprise, and with her costume jewelry becoming so popular, it was time to make a change. Helped by a new friend, Paul Iribe, whom she hired at first as a textile designer and later put in charge of jewels, she dazzled the press once again.

In November 1932 the world was in the doldrums of the Great Depression; even Chanel, whose fortune was rumored to be in the millions, had to reduce her prices. Yet, in her peculiar way of reversing popular attitudes, for the first time she introduced a collection of precious jewels. Venturing into an agreement with De Beers, she showed

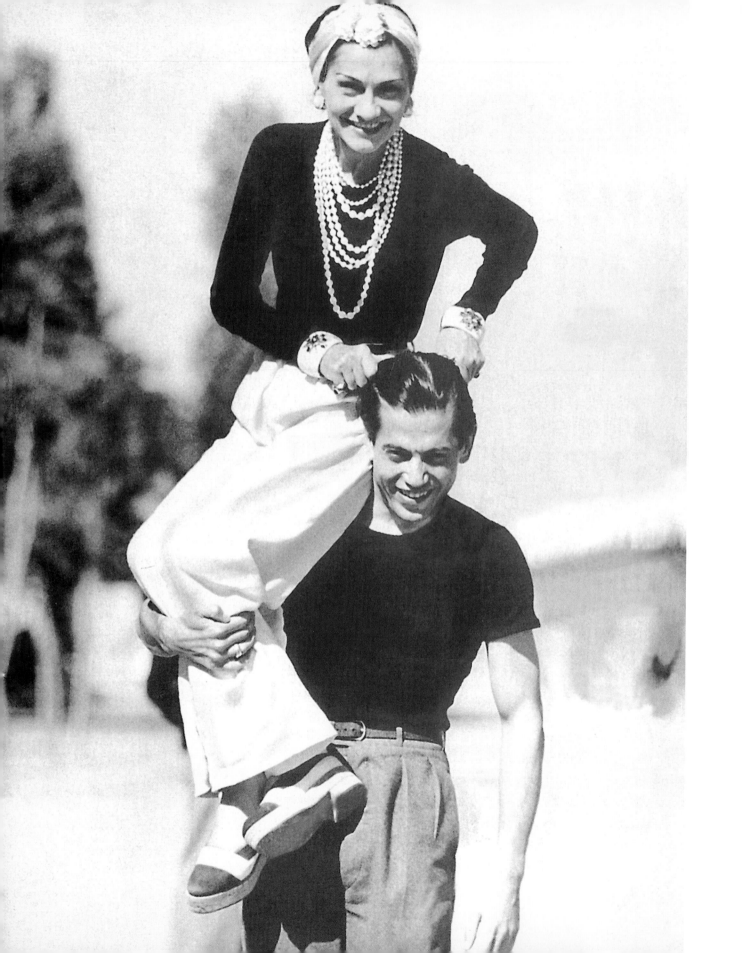

an array of fabulous diamonds designed by Iribe. His delicate displays of bows, knots and ribbons and his cosmic clusters of crescents, comets, stars and sun-rays drew enormous attention. He created a bracelet made of diamond fringe and a brooch in the form of a foot-long, flexible diamond feather. He cleverly shaped pieces to close without clasps, and, adding another element of surprise, enabled them to be dismantled and converted to other forms; tiaras turned into bracelets, brooches emerged from earrings and necklaces. So stunning was the show, installed on lifelike mannequins in Chanel's flat on the Faubourg Saint-Honoré, that De Beers's stock rose twenty points within two

LA PAUSA WAS FURNISHED *with spare rooms and heavily carved provincial furniture, reminiscent of Chanel's convent days.*

OPPOSITE: **CHANEL WAS HER** *own best model. Here, perched on the shoulders of Serge Lifar, she wears white trousers, a black jersey top, ropes of pearls, a jersey headband and flower, and her famous Verdura cuffs.*

CHANEL LIKED TO WATCH
her fashion shows surrounded by
friends on her carpeted circular stairs.
She could see the reactions on the
faces of the audience in the mirrors.

days of the exhibition's opening, and Chanel's name was once again in the news.

At forty-eight, the same age as Chanel, Iribe had just come back from a starlit turn in Hollywood when they began their collaboration. Brilliant and multitalented, he could take credit for a long list of achievements: a *succès de scandale* with a book of erotic illustrations of the fashions of Paul Poiret; he'd been a fashion illustrator and writer for

Vogue; an illustrator and editor of his own political publication; a designer of fabrics, furniture and rugs; an interior designer for socialites and celebrities; an art director for Cecil B. De Mille; and he was an ardent pursuer of women.

With his chubby frame, elfin face and gold-rimmed glasses, his image hardly projected sex appeal, yet Iribe practiced the art of seduction like other men practiced golf. When he and Chanel met in

CHANEL ENTERTAINED IN AN *easy manner at her house La Pausa in the South of France. Lunch was served buffet style. Here she is with one of her guests, the playwright Jean Hugo.*

PAUL IRIBE WAS ONE OF THE *few lovers Chanel considered marrying. They worked as a team and collaborated on a collection of fine jewelry.*

OPPOSITE: **CHANEL SEATED** *on her desk. She is wearing a favorite jersey suit with white collar and cuffs, bangle bracelets and a two-toned beret.*

1931, he was married for the second time and designing for Cartier; within months he was living with Chanel and working on projects for her. Intrigued by "the most complicated man" she had ever known, Chanel was attracted to his intelligence and refinement. He sparked the intellectual fire lacking in her relationship with Westminster, shared her exquisite taste and had an equal appreciation for luxury. As passionate and temperamental as she, he treated her with great affection one minute, and fought bitterly with her the next, harboring an envy of her huge success.

Nonetheless, won over by her lover's charms, Chanel financed his dream of bringing back his journal, *Le Témoin*. But even while he spent much of his time on the controversially nationalistic newspaper—for which he had her pose—he continued to work for her company. His textile patterns earned her high praise, and his optical illusions of rib-

Dangerous Flirtations

IF CUBISM WAS BORN FROM THE HORRORS of the First World War, Surrealism presaged the Second. The unexpected juxtapositions in the art world gave hint of the fascists and their inconceivable acts to come. In fashion, the absurdities were expressed by Elsa Schiaparelli, whose rise to prominence paralleled Chanel's return to Paris after Iribe's death. As smart as Chanel's clothes were, they melted in the shadow of her rival's preposterous combinations. If Chanel's talent was pragmatic, Schiaparelli's was bizarre. If Chanel was understated, Schiaparelli was over the top. Chanel, tired of holding her handbag, fastened a chain around it and slung it from her shoulder, while Schiaparelli fashioned her purse in the form of a telephone. Chanel simplified hats; Schiaparelli shaped them like shoes. The younger woman's penchant for outrageous ideas, from pockets that looked like lips to a broad brush of the color "shocking pink," drew enormous press coverage, irritating Chanel with every line. The clash rang out as the greatest fashion collision of the time. "That Italian artist who makes clothes"

CHANEL LIKED THE FEMININE *look of a black lace gown. Here she poses in her suite at the Hotel Ritz.*

OPPOSITE: **CHANEL OFTEN**
showed the bolero jacket in her
collections. Here she wears it with a
velvet-brocaded, white chiffon gown
and her own fabulous emeralds and
rubies.

...UCH OF HER LIFE,

suite at the

es the street

was the way Chanel referred to the only designer who truly enraged her. So great was the competition that, at a ball they both attended, Chanel invited Schiaparelli to dance and, steering her toward a candle-burning chandelier, caused her rival's dress to catch fire.

Paris seemed to be dancing faster and faster as the balls grew bigger, the costumes better, and imaginations went wild. At the Waltz Ball, hosted by the high-society figures Jean-Louis de Faucigny-Lucinge and Niki de Gunzburg, the theme was enlarged from an evening of Schoenbrunn on an island in the Bois de Boulogne to one, wrote Faucigny-Lucinge, that encompassed the Tuileries, the Residence of Munich and Scottish castles. Elsa Maxwell arrived as Napoleon III, Faucigny-Lucinge appeared as the Emperor Franz Josef; and guests masquerading as Empress Elizabeth, the Archduke Rudolph and tartaned kings came in costumes so splendid that the photographer Horst was assigned by *Vogue* to take their pictures in his studio. But for all the flaming colors and brilliant ideas, it was Chanel—dressed all in black, with a long-sleeved black taffeta gown, black pillbox headdress, and a huge bouquet

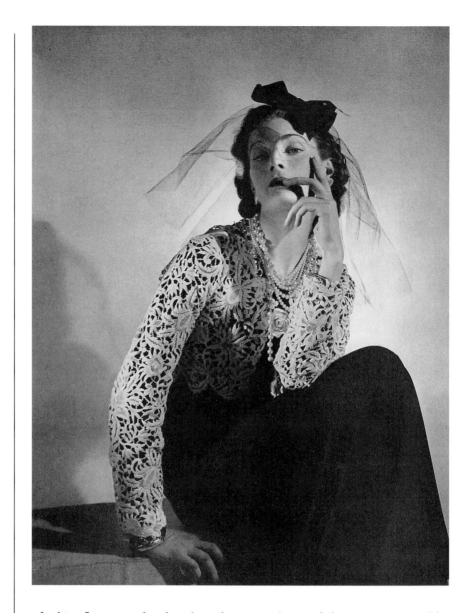

A WOMAN SHOULD BE A
butterfly, in the evening, Chanel said.
This lace evening gown topped with
a head veil and large bow was one of
the typically delicate evening looks
from her.

OPPOSITE: **AFTER THE STARK**
look of the 1920s came the romantic
era of the '30s. Chanel's flirtatious
and feminine pleated gold lamé gown
with bolero jacket is worn with a
whimsical flower headpiece and veil.

of white flowers in her hand—who created one of the most memorable looks of the evening.

Although it was the partying side of her life that the public saw, Chanel was far more comfortable at home with friends. By 1935 her newest interest was a young Italian aristocrat, Luchino Visconti, and like almost all of her cronies, he entered her life though his friendship with Misia Sert. Visconti was born to a rich and prominent Milanese family, and at twenty-six he was passionate about theater, opera and film, but uncertain about a career. Much of his time was spent traveling from Milan where he kept a stable of racehorses, to Munich where he visited art galleries, to Kitzbuehl where he skied, to the South of France

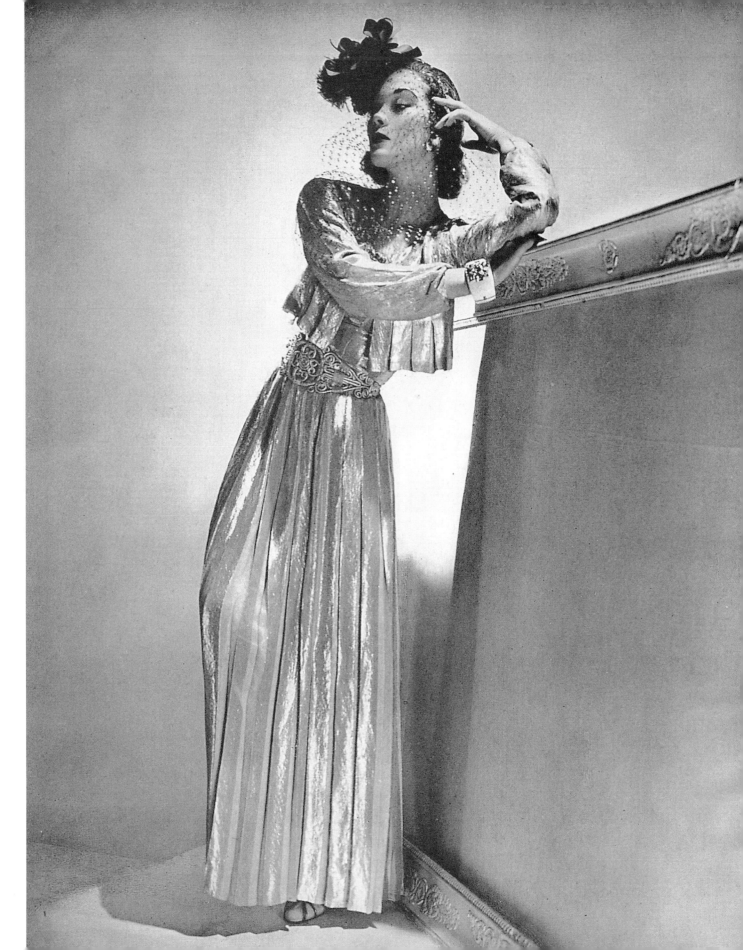

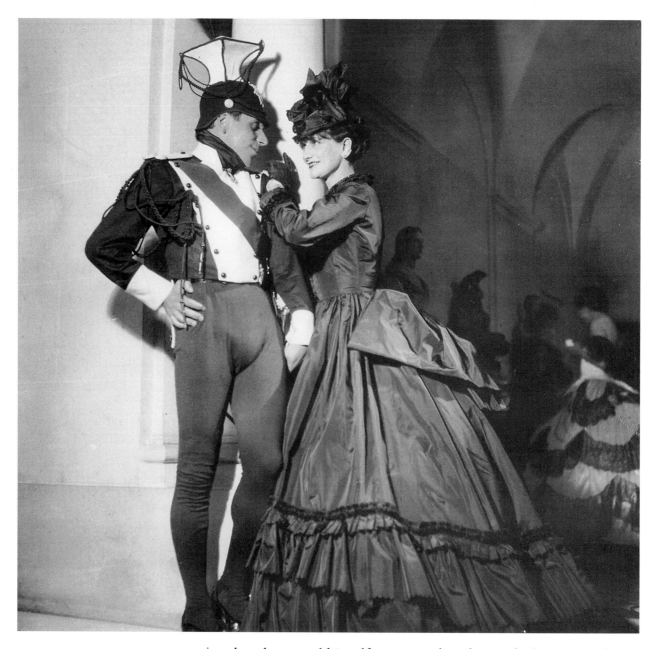

WHILE AMERICANS SUFFERED *during the Depression, society partied in Paris. Chanel attended the Bal de Valses dressed in a black satin gown and black headpiece. She is with the Count Fulco di Verdura.*

where he sunned himself, to Paris where he watched movies outlawed by the fascists. It was on one of his trips to Paris that he and Chanel met. Attracted to his dark good looks and elegant style, she immediately played the coquette, cozying up to the man who was less than half her age, inviting him to one of her famous lunches on the Rue Cambon.

Her private rooms above the salon had become the focal point for her entertaining. The year before, at the urging of Paul Iribe to simplify her life, Chanel had vacated the premises on the Faubourg Saint-Honoré and moved to a suite at the Hotel Ritz. But the bedroom at the

Ritz was bare-bones, austere and merely for sleeping. The possessions she truly loved—the Coromandel screens, crystal chandeliers, Oriental tables and bronze animals in pairs—she transferred to the Rue Cambon. There, in her four-room apartment, she spent most of her time, playing host, gathering friends to help ward off her solitude. Six or eight of her companions dined at her table, while she discoursed on whatever came into her mind. Commanding, demanding, dogmatic, rhetorical, she ruled the room with a husky voice and a hailstorm of words. But the camaraderie was so good, the conversation so clever, the loyalty so strong

ALWAYS ATHLETIC, CHANEL *climbs a tree at La Pausa. Her house was far more rustic than the other more formal homes on the Riviera.*

that, despite the arguments and temper tantrums, few friends refused
her offer; dining at Chanel's was a privilege almost no one ever turned
down. Stubborn and strong-willed, she had "the head of a black swan,"
said Cocteau, and "the heart of a black bull," said Colette, who—along
with artists such as Marie Laurencin, writers such as Maurice Sachs and
available men such as Visconti—sometimes joined the group.

Visconti followed as Chanel set the course for a romantic tryst. In-
trigued, he said, by her "feminine beauty, masculine intelligence and
fantastic energy," he was soon a steady visitor to her Paris apartment
and to La Pausa. He traveled with her to Italy and ventured on donkeys

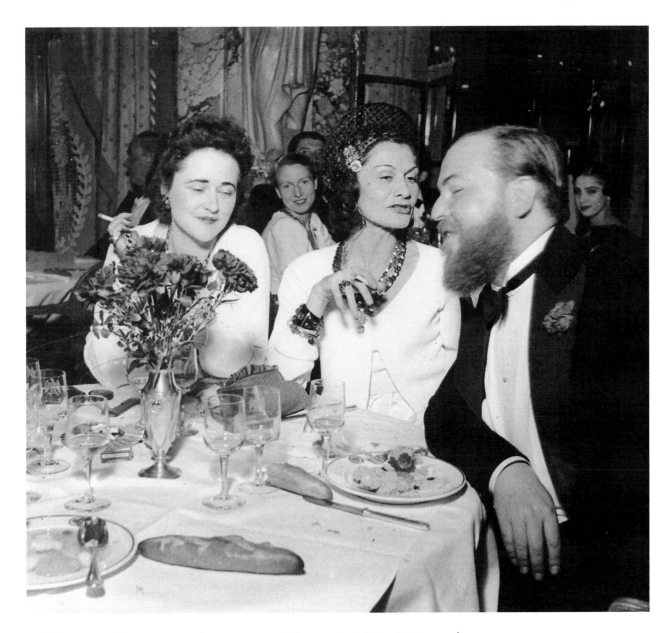

with her in southern France. "Visconti was infatuated with her," Diana Vreeland said, recalling how Chanel, dressed in white pants, pullover, beret and pearls, could be seen leading him up the hills above Roquebrune. And for a brief while they were lovers.

Romance seemed to be everywhere. In fashion, the harsh look of the twenties no longer prevailed, and even Chanel, who rejected arbitrary pronouncements of hem lengths or skirt widths, changed her style. Androgyny, along with the Jazz Age, had drifted away, replaced by waltzes, the Windsors and wistful memories of the Belle Epoque.

"A woman should be a caterpillar during the day and a butterfly at

CHANEL HAD A SHARP WIT *and a quick tongue. Here she is telling something amusing to Christian Bérard while the wife of Jean Hugo tries to listen.*

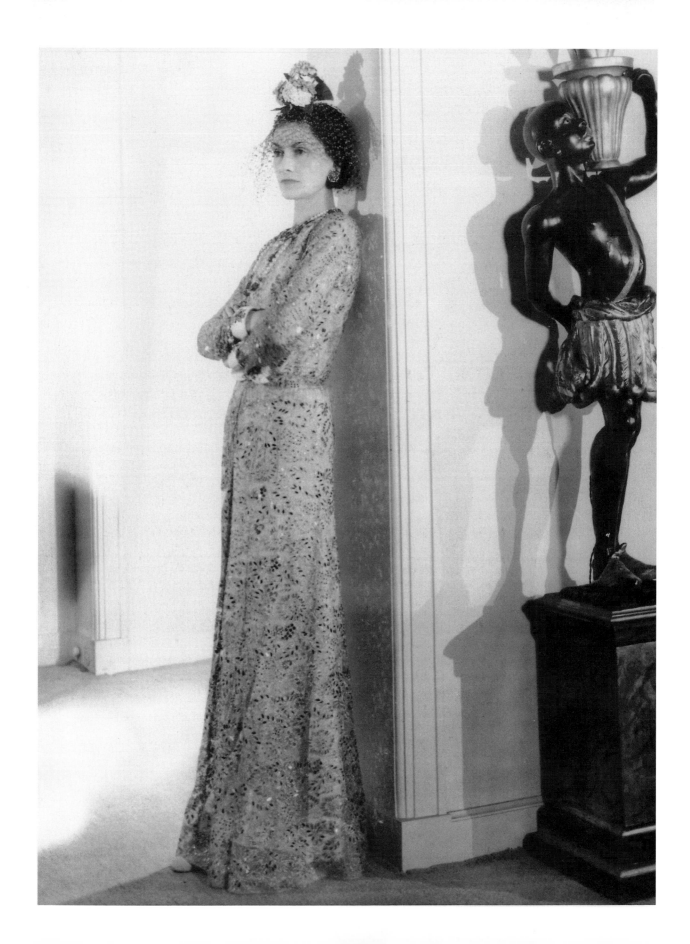

night," Chanel declared. Softened curves succeeded angular planes as she adorned herself and her clients in fragile evening gowns of delicate lace, whispery chiffon and fluffy tulle. And although she avoided such frothy looks for day, she applauded the female figure, cocooning it in gypsy dresses and narrow-waisted suits. Her signature looks were still important, her jersey suits and crisp white trims still in demand. The photographer Louise Dahl-Wolfe favored Chanel's sleeveless, navy wool jersey dress with a set-in white piqué bib, worn with a white piqué vest, a navy jacket and detachable white cuffs. But if the jersey ensemble was a staple, there were more flamboyant clothes, like the blue fur

THE CUT OF CLOTHING WAS *essential to Chanel. The armholes had to be high, the sleeves narrow, and the jacket had to be weighted for a smooth line.*

OPPOSITE: THE ROMANTIC *look of the 1920s is well expressed in Chanel's bead-encrusted evening gown. In her hair she wears a pailletted veil topped with a camellia.*

capelet bought by Wallis Simpson (a steady customer at Schiaparelli's) before she married the Duke of Windsor. And Diana Vreeland, a loyal client in the thirties, fondly remembered Chanel's brocades, boleros, full skirts, pailletted veils and flowers in the hair. Vreeland proclaimed her own favorite outfit to be a huge skirt of silver lamé, quilted and weighted in pearls, worn with a linen lace shirt and, over it, a lace bolero encrusted with diamanté and pearls. It was, she said, "the most beautiful dress I've ever owned."

Chanel's insistence on femininity was now reflected not only in her clothes but in her accessories. Roses and gardenias became a frequent theme, but it was particularly the camellia, evoked so exquisitely in the novel by Alexandre Dumas fils, that carried the imagery of the times. Adored by nineteenth-century aristocratic women who claimed the white-petaled flower as a necessary adornment, it had also become the symbol of the courtesan and the cross of the self-destructive lover. For

OPPOSITE: **CHANEL LIKED TO** *wear fur to protect her from cold. Here she is in an astrakhan three-quarters coat and cloche hat.*

CHANEL WORKED DIRECTLY *with fabric and never did drawings for her clothing, but she is shown here working on a textile pattern.*

Sarah Bernhardt, who played the title role in *La Dame aux Camélias* on stage, it provided theatrical success, and it proved the same for Greta Garbo who acted the role of Camille in the 1937 film. Chanel latched onto the fantasy of the Oriental flower, turning it into her icon. Translating the flower into enameled jewelry or fabric, she pinned it flirtatiously in the hair, perched it provocatively on a veil, rested it insouciantly at the waist or innocently at the neck. As recognizable as her ropes of pearls and lacquered cuffs, it became another signature look for Chanel.

Although her evening clothes were as glamorous as ever—gowns of pleated lamé or pailletted lace— and her daytime suits were in smart tweeds, Chanel was slowly slipping out of the limelight: she was replaced in the fashion press by Mainbocher,

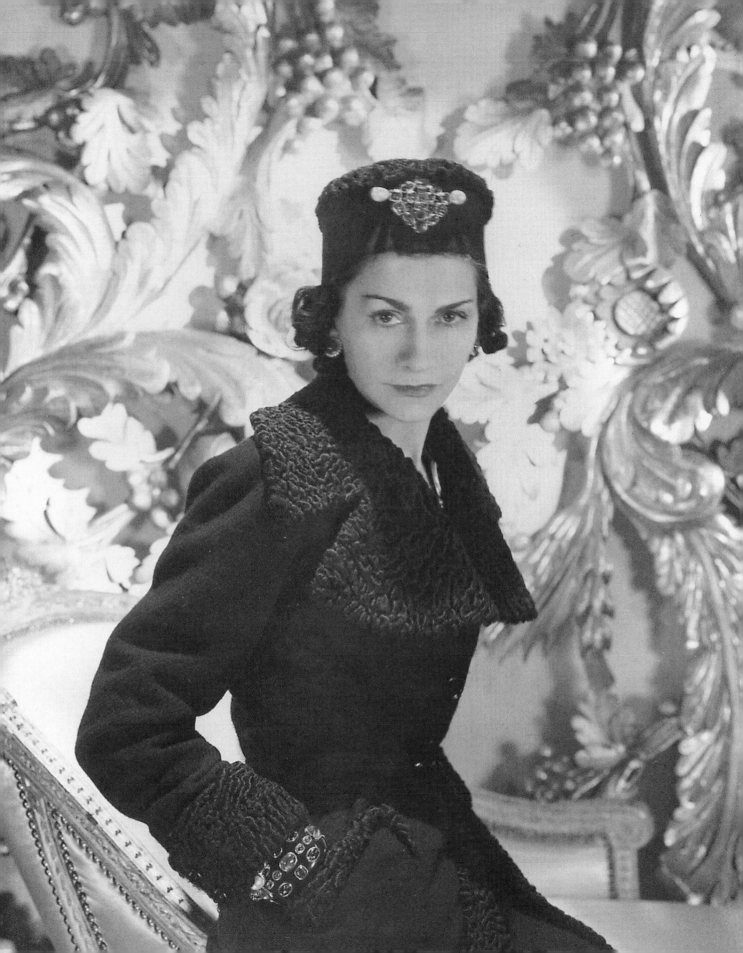

AT A BALL GIVEN BY THE
Count de Beaumont, Chanel (right)
came as Watteau's Indifference. She
is standing with the Countess de
Montgomery and Serge Lifar. (1938)

CHANEL WATCHES A MODEL
wearing a "Watteau" suit, inspired by the costume the designer wore to the Count de Beaumont's ball.

Molyneux, Madame Grès and Schiaparelli; replaced by the Wertheimers in her boardroom post as president of Parfums Chanel; replaced by her lover Visconti with the male photographer Horst, and almost replaced by her staff who, demanding larger salaries and benefits, refused to let her in when she came to work at her own salon. It was part of a series of workers' strikes spurred on by the Socialists who were elected to power in the French parliament. In the month of June 1936, following the election of the Popular Front, led by Léon Blum, more than twelve thousand strikes took place around the country. Although Chanel's stubbornness won out and her workers agreed to return to their jobs on her terms, her lust for business was waning.

Perhaps to drive away her loneliness, she partied more than ever; and she still posed for magazines, though less frequently, acting always as her own best model. Even in her fifties, she was stunning. Artists such as Bébé Bérard sketched her picture in tulle, paillettes and plumes for the Pavilion of Elegance, the chic and highly praised exhibit at the 1937 Paris World's Fair. Photographers including Cecil Beaton and Horst, spent hours making love to her with their lenses, producing exquisite portraits of a golden-skinned, dark-eyed beauty, pearls or gold always around her neck, a cigarette always between her fingers.

Once more she became involved with the theater, teaming up with Cocteau and creating costumes for his productions of *Oedipus Rex* and *Les Chevaliers de la Table Ronde*. And after introducing Visconti to the director Jean Renoir, marking the beginning of the Italian filmmaker's career, she created costumes for Renoir's important movie *La Règle du*

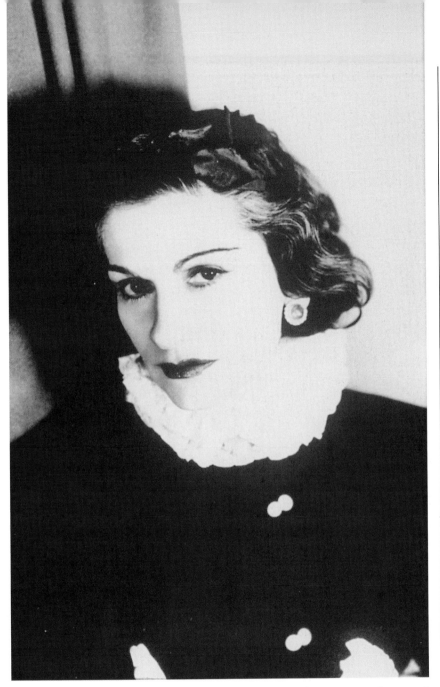

Jeu. She worked with Salvador Dali too, inviting him to spend several months at Roquebrune, where they collaborated on costumes for the *Ballet Bacchanales.* "There was a biological determinism to her career in haute couture," Dali said, observing her drive and her style; "she has the best-dressed body and soul in the world."

But Chanel's mood was darkening as the mood in France clouded over. Politics was becoming the consuming passion of even the unpolitical, reflected in their conversations and in their clothes. As the Fascist Franco fought the Communists in a civil war in Spain and Hitler retook

the Rhineland, neutralized after the First World War, Frenchmen argued in cafés over the aggression of the Germans. But the general opinion was that no one wanted another war. "What's the worst that can happen if Germany invades France?" asked the novelist Jean Giono. "For my part, I prefer being a living German than a dead Frenchman."

The inconceivable, as suggested by the Surrealists, was eerily coming to life. Communists sported red scarves, Nazis swaggered in brown shirts and Fascist sympathizers puffed their chests in black shirts, while the sound of boots and gunshots thundered across Europe. In March 1938, Hitler's troops stomped first into Austria and then into Czechoslovakia. In France more than two million men were mobilized and sent

CHANEL LIKED TO BE *surrounded by friends. She is shown here with the artist Salvador Dali (left), the artist/playwright Jean Cocteau (center), Madame Dali and M. Samosa.*

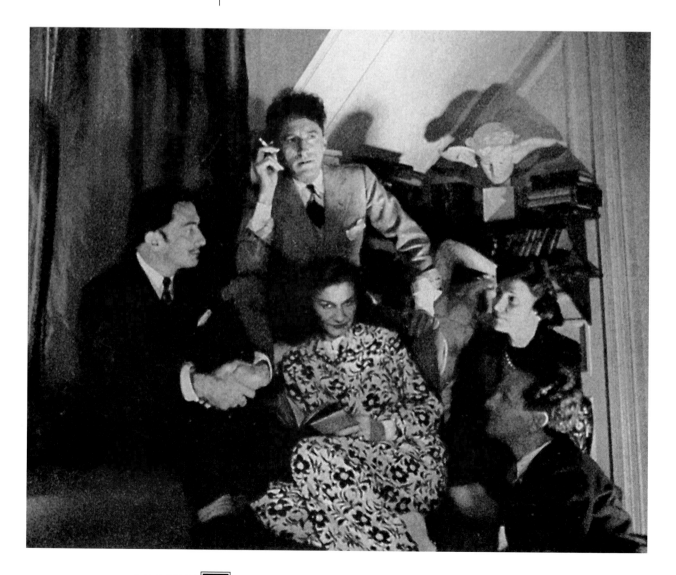

on their way to the northern border with Germany. This time, Chanel knew, the battle would not be to her advantage.

Then, with a single sigh of relief, most of the country breathed more easily as the Munich Accords were announced and the British Prime Minister Neville Chamberlain declared peace. Paris went wild as the King and Queen of England paid a visit to France confirming that all was well in Europe. Parties broke out everywhere in the summer of 1939. Lady Mendl threw a bash for three elephants and 750 people at Versailles. Louise Macy furnished an empty mansion with several thousand candles and insisted that her guests wear as many diamonds and diadems as they could bear. And at one of the last celebrations before the war, the Count de Beaumont hosted a ball celebrating the three hundredth anniversary of the playwright Racine. The Baron de Rothschild, dressed as an Ottoman sultan, boasted the family diamonds in his turban and his sash. Madame Marie-Louise Bousquet, the representative of *Harper's Bazaar* in Paris, masqueraded as La Vallière, a future nun, and Chanel arrived in a satin costume she titled "Watteau's Indifference." But the follies were soon to be over. As the Nazis marched toward Poland, France announced a general call to arms, and ordinary citizens read posted warnings of enemy bombs, gas attacks and blackouts.

Toward the end of the month, the City of Light was nearly dark, the museums closed, the cathedrals sandbagged; anyone who could do so was asked to leave Paris. On September 3, 1939, after the Nazis stampeded Poland, France declared war on Germany. A few days later, wary, weary and maybe even indifferent, Chanel announced she was closing the doors of her couture business. No one cared about clothes.

By June 1940, Chanel had packed her belongings in trunks, stored them in the hallways of the Hotel Ritz, and fled Paris. Two and a half million others had also escaped the city. That was grounds, said the head of state Maréchal Pétain, to capitulate to the Nazis. While the German soldiers marched in and occupied Paris, Chanel found herself near Pau; but in the town where once she had been starry-eyed at the sight of Boy Capel, she was now bleary with boredom. When a telegram informed her that, despite their occupation of the hotel, the Germans wanted her to come back, she made a fast getaway and returned to Paris.

Ensconced at the Ritz, she soon began a love affair with Baron Hans Gunther von Dincklage, called "Spatz," an aristocratic intelligence officer she had known casually before the war. Born to a German baron

and an English mother, he had lived in Paris for a number of years, and, for his cultured background and cultivated manners, had been kept by a number of women. To hide his espionage work, von Dincklage claimed a number of covers, including attaché at the German embassy. He told Chanel he was in charge of textiles. He spoke only English to her, and vowed that he was madly attracted to her although more than ten years her junior. During the Occupation, he was a means to ward off her loneliness and a way of protecting herself.

But the price of keeping a Nazi lover was dear. Not only did "Spatz" ("The Sparrow") prefer fine wine, good cigars and well-tailored clothes, he preferred staying out of public view. Afraid that his presence would spark an order from his superiors to leave Paris, he spent most of his time on the Rue Cambon or traveling with Chanel between her house on the Riviera and a villa she had rented in Switzerland near Lausanne. Rejected by almost everyone she knew, Chanel rarely saw friends and lunched only once in a while with Serge Lifar or the newly rejoined José-Maria and Misia Sert, or Jean Cocteau and his lover Jean Marais. Riding the metro underground to get where she needed to go, like everyone else in the bleak cold winters, she survived as best she could, paying black-market prices for good food and enough heat, claiming, in spite of her money, that her fingers were swollen from chilblains. Although her shop still sold perfume to German soldiers seeking gifts for home, sales were limited to twenty bottles a day and her income dropped to five thousand dollars a year. Her career was apparently over, and even her attempts to start again as a singer led nowhere. Other couturiers, like Molyneux, Mainbocher, Schiaparelli and Worth, had left the country, but Chanel did not want to leave France. The best she could do was keep her profile low and try to endure.

In a moment of exhilaration, toward the end of the war she thought she could help make peace. In a scheme to avoid the unconditional surrender of the Germans, which Winston Churchill had already announced was in the works, she hoped to convince the British leader to sign a treaty with the enemy and help the Germans save face. She was given permission by the Nazis to leave France and pursue the plan, and tried to see her old acquaintance Churchill on a trip he was making to Spain. But the meeting never took place, the plan failed, and as the Germans went down in defeat, Chanel went down in disgrace. Arrested after the Liberation, she escaped imprisonment and public humiliation, perhaps with the help

THE CLASSIC CHANEL LOOK: *an easy cardigan jacket and skirt, crisp white blouse and jewelry. Her earrings are half flowers made of pearls set in gold; her necklaces are gold chains studded with colored stones.*

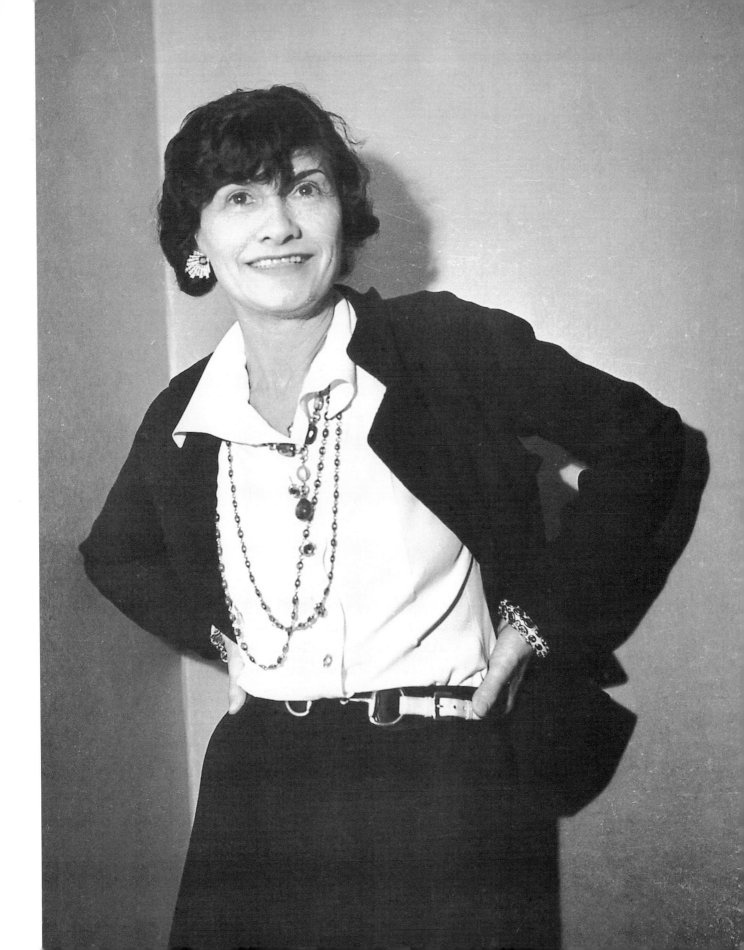

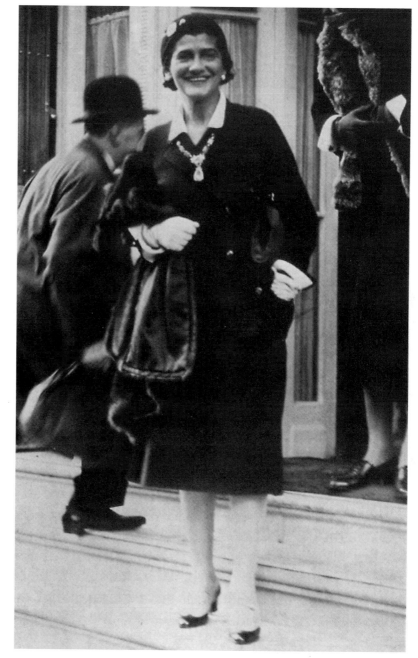

of Churchill, and after a brief stay in a small pension, exiled herself to Lausanne. Asked about von Dincklage, she said, "At my age, when a man wants to sleep with you, you don't ask to see his passport."

The final insult came through fashion. Too many years of war rations and restraint had made women eager to embellish their figures. Just as Chanel had turned clothing on its heels following the First World War, so did Christian Dior do now in the bubbly postwar period.

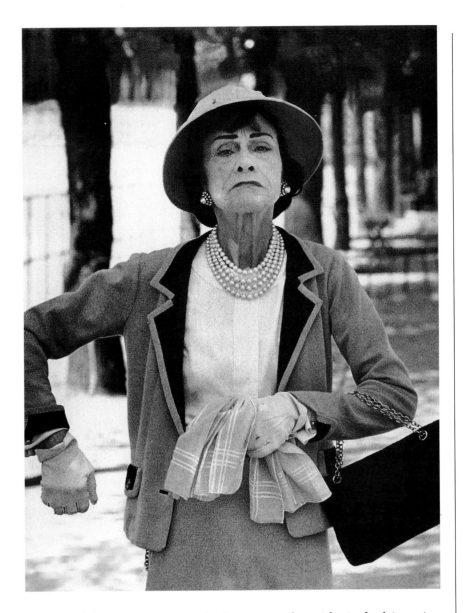

WEARING HER CLASSIC
jersey suit, a pearl necklace and pearl earrings, and her signature chain-handled bag, Chanel is determined to make a comeback.

His boned corselettes worn under bosomy styles with pinched-in waists and full, crinolined skirts were a welcomed return to the Belle Epoque. To Chanel, his old-fashioned undergarments and overdone clothes were almost a personal insult. Walking down the street with the film director Franco Zeffirelli, she pointed out some fashionably dressed women, and as she had once scoffed at the courtesans trying to balance themselves with their huge hats, so did she now make fun of the females tottering in their ankle-length skirts and high heels. "They can barely walk," she sneered. And sensing that these modern women, driving behind the wheel of a car or sitting behind a desk, would soon feel disgust with clothes that constrained them, she planned her own return.

Lucky Number

FIVE WAS HER LUCKY NUMBER, she said, and lucky it was for her that her fragrance was one of the most popular in the world. As the war came to a close in Europe, German soldiers were replaced by GIs, lined up on the Rue Cambon, patiently waiting to receive free gifts of Chanel No. 5 to bring back to their wives and sweethearts. And in America, the Wertheimer family, who had left Paris in 1940, was still producing the perfume in New York.

The Wertheimers' claim reached back to the early days of the fragrance. In 1923 they had been introduced to Chanel by a mutual friend, Théophile Bader, founder of the Galeries Lafayette department stores. Pierre Wertheimer, a charming businessman who owned a stable of racehorses and a sizable cosmetics and fragrance company, had been seeking new products for his business, Bourjois, which was the largest of its kind in France. Chanel, who was underfinanced and selling her fragrance only in her boutiques, was eager to find someone who could manufacture and distribute her perfume on a

CHANEL ALWAYS LIKED *tiered evening dresses. This one, in navy blue and uncrushable, is from her comeback collection, and is made of bubbly nylon seersucker.*

135

ABOVE, LEFT: **THIS METALLIC**
gold chain necklace composed of
ancient-looking coins is similar to one
seen on Chanel in a photograph by
Horst. It is signed CHANEL *in script.*

ABOVE, RIGHT: **THE**
exquisite emeralds given to her by the
Duke of Westminster inspired this
rhinestone and green glass necklace
with matching ear drops. It was made
by Gripoix and used on the runway
for a couture show.

RIGHT: **THIS SET OF**
necklace and matching earrings by
Gripoix is made of red poured glass
and simulated mother of pearls.

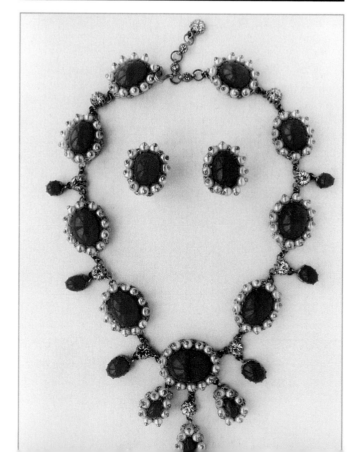

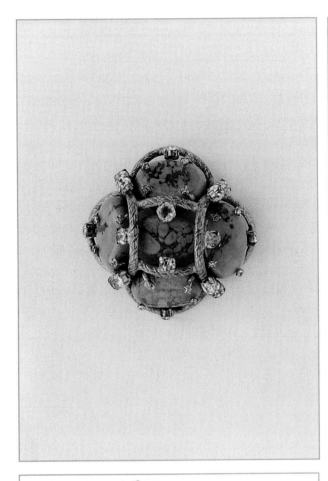

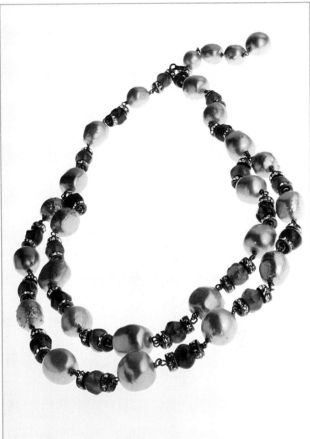

ABOVE, LEFT: **CHANEL LOVED** *the look of a brooch. This one, signed* CHANEL, *was made by Goossens from simulated turquoise and gold metal braid.*

ABOVE, RIGHT: **CHANEL** *often wore double chains, such as this one made of simulated pearls, rubies and emerald stones. The baroque pearls are in varying shades of pink, green and white.*

LEFT: **THIS DOUBLE GOLD** *chain made by Goossens has gold filigree baubles with centers of pearls, malachite and rose glass.*

broader scale. In 1924, three years after the initial launch of the fragrance, Pierre Wertheimer became a partner with Chanel. Along with Bader, the threesome formed a new corporation, Parfums Chanel, which dealt only with the perfume and beauty products: Wertheimer received 70 percent of the stock, a reasonable amount for manufacturing and selling the product; Bader took 20 percent as his finder's fee; and Chanel retained 10 percent plus the title of president in recognition of creating the fragrance. The rest of the Chanel products—clothes and accessories—were still owned one hundred percent by Chanel.

Within a short time the perfume became a staggering success. New fragrances were added to the line: "No. 22" was launched in 1922, "Gar-

THE COMEBACK SUIT, A *perfect combination of an easy cardigan jacket and pocketed skirt, worn with a crisp white blouse with turned-back cuffs, a perky bow at the neck, and a large bow in the hair. Although it defied Dior's New Look and displeased the French, the American editor of* Vogue *liked it at once.*

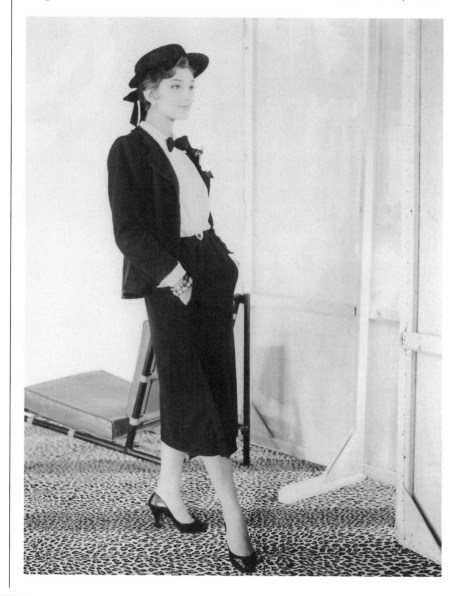

denia" in 1925, "Bois des Iles" in 1926 and "Cuir de Russie" in 1927.
And though none of the others were as popular, by 1929 the company
could proclaim Chanel No. 5 to be the largest-selling perfume in the
world. But if Parfums Chanel enjoyed enormous sales, Chanel herself
could take little pleasure in the profits. Her sharp business acumen had
been dulled in her dealings with Wertheimer. Angry at herself and with
him, Chanel tried to gain a larger share of the company, but to no avail.
In 1934, a decade after the corporation was formed, she hired a lawyer
to wrest greater control and started a lawsuit against her partner. The

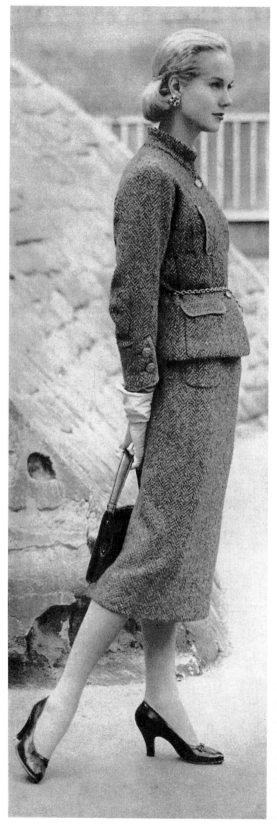

only result was that Chanel was removed from her seat in the boardroom.

Eight years later, during the war, Chanel tried to take her revenge. The Nazi laws against Jewish businesses seemed to be in her favor; companies that were left behind by people who had fled the country were legally allowed to be taken over by Aryans. With the Wertheimers' Jewish background, Chanel thought she could claim her right to the company and seize it from them. But the family had made a shrewd move; before escaping to the United States, they had put their stock in the hands of a former business partner, Félix Amiot, a French aviation dealer who sold weapons to the Germans. Amiot would own the rights to the company and return the shares after the war. Chanel found herself up against a wall. Despite her claims and her intimate relationship with von Dincklage, a Nazi officer, the occupying government refused to grant her the business. They needed the weapons from Amiot more than they needed her.

It outraged her even further to discover that the Wertheimers had smuggled the formula for Chanel No. 5 out of France and had begun manufacturing the fragrance in New York. Their business was not only alive, it was flourishing in the States. Angry at their new success, Chanel began manufacturing and selling her own version of the perfume, "Mademoiselle Chanel No. 5," in Lausanne. But there was little clamor for her product, and with much of her money dissipated during the war years on high rents, bribes, the black market and the expensive desires of her straitened lover, Chanel decided to approach the Wertheimers once more.

In 1947 she made a trip to New York and negotiated a new contract with her partners. In addition to a lump sum of $400,000, plus a monthly allowance, they agreed to pay all of her living expenses—rent, food, taxes and business costs—plus 2 percent of the gross sales (close to a million dollars a year) in exchange for all her shares in the fragrance business. Feeling more secure, Chanel returned to France. "I shall never have to work again," she told her lawyer.

For several more years she lived in semi-retirement, restless and bored; customers seeking out her boutique on the Rue Cambon could buy fragrance, accessories and a few sweaters and skirts she had for sale, but her couture business was still closed. As she watched women struggle with the complicated designs of Christian Dior and Cristobal Balenciaga, however, she felt encouraged to try once more to sell her simplified clothes. And the success of a debutante gown she made for the daughter of a socialite friend re-established her belief in herself. Determined to make a comeback, but without the funds to do it, in 1953 she approached the Wertheimers once again. Knowing that a successful venture in couture would strengthen the name Chanel and give a boost to the sales of their fragrance, the family agreed to finance her. This time she consented to relinquish ownership in all her businesses, but she would retain control over the designs.

She was seventy years old, as vigorous as when she had shut her doors in 1939, and doggedly determined to show the world what she knew. Sadly, her friends the Grand Duke Dimitri, the Serts and the Duke of Westminster all had died, but the idea of going back in business rejuvenated her. Irascible and exhilarated, Chanel began her preparations. A team had to be assembled and a total of 350 workers had to be hired: Madame Manon, the head of her top workroom during the 1930s, was asked to direct her new atelier. A small, sprightly woman devoted to the designer, Manon was so trusted that she made the clothes Chanel actually wore. Other workers had to be hired as well: fitters, cutters, pattern-makers, seamstresses were called upon to come back to work, and new ones found to replace those not available. Fabrics were sampled, every one carefully chosen by Chanel: for daytime clothes she wanted her proverbial jerseys in silks as well as wools, and soft tweeds in wools, linens or silks; for evening she looked for laces, chiffons and brocades. Braids, buttons and trims had to be ordered, and lightweight silks to be used as linings and for blouses. Slowly, the pieces of the puzzle were fitting together.

For nearly a year Chanel worked on the collec-

OPPOSITE: **CHANEL'S TWEEDS** *became as famous as her jerseys. This suit, shown soon after her comeback, was in mauve and pink herringbone and worn with a cuffed cashmere sweater. The jacket buttons look like old coins.*

SUZY PARKER, ONE OF HER *favorite models, shown in* Vogue *wearing pearl earrings and the signature Chanel silk camellia at the nape of her neck.*

THE RUFF RETURNED IN A *boa of feathers topping this windowpane evening suit done in gold and white brocade. Chanel was one of the first to introduce the idea of clothes that could be worn from day into evening.*

OPPOSITE: **MAKING A STRONG** *statement in tweed, Chanel used a black and white fabric not only for this cardigan collared jacket and softly pleated skirt, but for the matching hat and shoulder bag.*

tion. Still using her suite at the Ritz as her bedroom, she woke early in the morning, ate her breakfast of porridge and prepared for the day. Her working uniform was a tweed suit, and though she had many to choose from, each was almost identical to the next; her favorite combination was beige with red and navy trim. Sometime before noon she would dash across the Rue Cambon, and as soon as someone on her staff caught a glimpse of her crossing the street, her assistants would pull out bottles of Chanel No. 5 and rush to spray the entrance, the stairs and the salon. Whiffs of the fragrance wafted wherever she walked. Climbing the three steep flights to her workrooms, she would begin the fittings for the day.

Models in white smocks waited for Mademoiselle to appear. One by one they were called before her, and with her face scrunched in a determined grimace, her scissors on a cord around her neck, a pile of pins nearby, once again she set to work, pushing and pulling the fabric into place, setting and resetting a collar, tugging at a waistband, tearing out a sleeve to make it higher, jabbing the air with her orders and her cigarette. The jackets had to be loose, hanging effortlessly from the shoulder, the armholes had to be molded high, the sleeves had to be skinny. The skirt had to move with ease and the pockets had to fall exactly right for the hands to slide in. Like a sculptor chiseling away at her medium, she was always improving, always paring down. The secret of her success, she knew, was in the fit: the more comfortable an outfit was to wear, the more elegant the woman who wore it.

Again and again she ripped apart the seams and redid them, tore out the shoulders and reset them, and finally, on the last night before her show, after cutting and pinning and sewing some more to make sure that "the underside is as perfect as the outside," she lay down on her back on the floor of the salon and checked to make sure that every hem was stitched correctly in place. Then, from a box of accessories, she chose the right flower, the best bracelets, the exact earring, the correct length of pearls for each out-

CHANEL'S ROMANTIC LOOK
of black lace appeared in Vogue *in a
Spanish-influenced spaghetti-strap
short evening dress.*

OPPOSITE: **THE FLIRTATIOUS**
*tiered evening dress was always part
of Chanel's collections. Here it is
shown in* Vogue *in a pleated black
chiffon. Both the original and copies
were sold in the United States.*

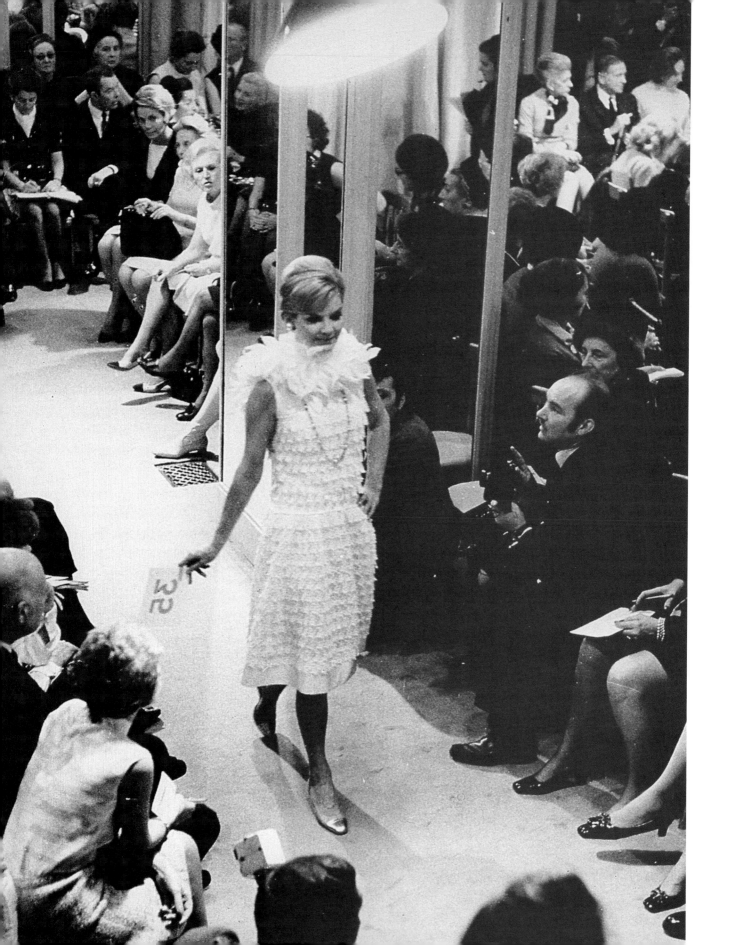

fit. And on February 5, 1954, with unfluttering self-confidence, she launched her new collection.

A throng of international buyers and press pushed to enter the showroom on the Rue Cambon. From America came Bettina Ballard of *Vogue*, Carmel Snow of *Harper's Bazaar* and Sally Kirkland of *Life;* from Paris came the magazine editors of *Vogue, Elle, Paris Match* and *Marie Claire,* and newspaper editors from *L'Oracle, Combat, Figaro* and the rest. There were buyers from B. Altman, Hattie Carnegie and Lord & Taylor in America, and from stores in Paris and London. Her old friends Boris Kochno and Franco Zeffirelli made their way in, taking their places on the ballroom chairs in the large salon, while others who could not find seats stood in the back. With her clique close by, Chanel, wearing a simple jersey cardigan jacket and easy skirt, positioned herself in her usual place high up on the curved stairs. Her black eyes sparkled like sequins, her sharp cheeks glowed like gold, her red lips puffed on a cigarette as she watched.

No flowers festooned the room, no music beat to a tempo. Slowly the first model emerged, gliding as Chanel had taught her, neck stretched long, shoulders rolled back, hips thrust out, one hand in a pocket, the other holding a card with the style number on it. Wearing a black coat and matching skirt with a crisp white blouse, the girl and her clothes seemed reminiscent of Chanel in the twenties and thirties. One after another, the rest of the models followed, their pace five or six steps apart. Their hair pulled back with large bows, their figures small and neat, they floated by in dark jersey suits, some with patch-pocketed vests and long-sleeve blouses, some with schoolgirl coats, others with short crisp jackets, all with matching skirts skimming the knee. Others followed in dresses with matching coats and shirtwaist dresses paneled in contrasting colors. As the show moved from simple daytime looks to cocktail and evening clothes, a flurry of soft dresses appeared. Matte jersey or mousseline, crystal-pleated nylon gowns in tiers, gowns of white lace trimmed with red, or red lace trimmed with black, and brocade suits trimmed with gold danced across the room.

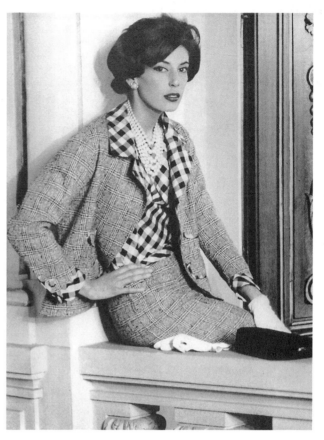

AN INTERESTING

combination of a tweedy glen-plaid suit shown with a contrasting plaid blouse, its collar and cuffs matching the plaid of the suit's lining.

OPPOSITE: **THE RUFF**

neckline for evening tops a whispery light silk dress. Chanel insisted on showing her collections without music in her salon on the Rue Cambon. The model walks in a typical Chanel pose, one hand on her hips, one hand holding a card with the style number on it.

From her seat at the top of the mirrored stairs, a taut, intense Chanel followed the expressions on the faces in the audience. The mood was far less welcoming than she had expected. The press, once a corps of smiling support, now greeted her clothes with a bitter frown, and the buyers cocked their brows with a question mark. They had come with a cynical air to see how the woman who claimed herself to be the essence of modernity could dare try to change the modern look. The ingenuous clothes she showed now were as different from the curvaceous styles of the New Look as her gamine outfits had been from the fantasies of Poiret during the First World War. But fashion is sacred in France, and Christian Dior had become the new god of the French; by trying to topple him, Chanel was seen as the antichrist. The crowd grimaced, and a

THE ACTRESS ROMY
Schneider became a client of Chanel's after the designer's comeback. On the set of a movie, she is wearing an update of the Little Black Dress: a simple black sheath with a feminine bow at the neck, pearls and signature beige/black slingback Chanel shoes.

OPPOSITE: **CHANEL USED HER**
apartment above the salon on the Rue Cambon for entertaining friends. It had a luxurious atmosphere with Coromandel screens, Oriental tables, bronze animals and ornate mirrors. The knickknacks on the table included chased silver boxes lined in gold, gifts from the Duke of Westminster.

PRINCESS GRACE OF

Monaco (former actress Grace Kelly)
was partial to suits by Chanel. She is
shown here at a royal palace
Christmas party in 1967, wearing a
tweed Chanel suit with contrast braid
around the cardigan jacket.

snicker zigzagged across the icy hush. Franco Zeffirelli watched and thought it "one of the cruelest experiences I'd ever witnessed."

When the magazines appeared on the newsstands, it was clear that the French and English had tossed her off with disdain, calling her collection a "melancholy retrospective" and a "fiasco." But if the European press was cruelly dismissive, the Americans were more courteous. *Life* welcomed her back, and American *Vogue* even gave her a round of applause. "The Chanel look, as specific as H_2O, meant a combination of youth, comfort, jersey, pearls, of luxury hidden away," said *Vogue*, in the issue published at the time of her opening.

The month following her show, the magazine featured a spread of three outfits worn by the new Chanel model, Marie-Hélène Arnaud. Both the V-neck draped red jersey dress, shown with ropes of pearls, and the tiered seersucker evening gown that moved effortlessly across a room or wrinkle-free across a continent, projected the nonchalance associated with Chanel. But what the editor and her readers had really

ARNAUD DE ROSNAY,
*another favorite model of Chanel's,
wears a tweed suit closed with a
metallic gold-mesh belt. Around her
neck is another favorite, the Maltese
cross.*

earrings made of pearl or colored stone set in gold. Chanel's astrological symbol, the lion, soon appeared in everything from talismans on chains to brooches to buttons, and interlocking C's materialized as well.

Expanding her collection of accessories, she brought out other ideas from the past and made them look new again. Her flowers rebloomed as fabric pins and hair adornments. Her shoulder bag, created in the thir-

THIS SHORT RUFFLED BLACK
*dress was done for the actress
Delphine Seyrig, who starred in 1961
in Alain Resnais's film* Last Year at
Marienbad.

BLACK WAS AN IMPORTANT
*color for Chanel right from the start.
She shows it here in a bouclé V-neck
cardigan jacket with jeweled buttons.
The gold-chained shoulder bag
became one of the status symbols of
the twentieth century.*

ties, was reintroduced in 1955, slimmed, squared and quilted in leather or jersey, set to become the status symbol for the second half of the century. Her two-tone shoes, popular in the twenties, emerged with a brand-new slant when she shaped them into low-heeled, sling-backed pumps. Like everything else she did, the shoes were young, pretty and practical: the black toe made the foot look small, the open beige vamp made the leg look long and sexy, and the low heels made walking effortless.

So huge was Chanel's return success that in 1957 the prestigious store Neiman Marcus invited her to receive an award as the most significant designer of the past fifty years, and New Orleans gave her the keys to the city. On her way back from Texas she stopped in New York to appear at the Fashion Group; while she showed off her crisp new suits, other designers were represented by dresses they called "sacks." She sneered at their abuse of femininity. In her Waldorf Towers hotel room, where she wore a straw-colored silk suit with a white blouse and cuff-linked sleeves, adorned with lots of jewelry, she sat for an interview with *The New Yorker*. Her designs "have begun to affect women's styles (and apparently, women's minds) every bit as powerfully as her designs of thirty-odd years ago did," the magazine said, calling her a "formidable charmer" with "the unquenchable vitality of a twenty-year-old." Nan Robertson, who interviewed her for the *New York Times*, still remembers that her looks were "strikingly handsome" and her personality "snappy, feisty and forthright."

In Paris she still held reign in her flat on the Rue Cambon, hosting luncheons now for the American press. If the cast of characters at her table had changed, her own character had not. Concentrating her attention on one particular guest each day, she glued them to their seats with her eyes and words, intentionally not letting them leave. "She'd keep me until three o'clock, so it would be too late for me to go to the other collections," remembers the publicist Eleanor Lambert with a smile of admiration. Clamping the arm of her visitor, Chanel would talk without a breath, her rapid-fire words as witty as when she was young. But if the wit was still there, the wealth had melted between her fingers. "I've made fortunes with pearls

THE SHARP LOOK OF BLACK
*and white in jersey. Chanel designed
this suit in 1970 with a long tunic
jacket, a look that she first did in
1916. The starched white collar and
cuffs, floppy black bow and chains are
all typical Chanel looks.*

OPPOSITE: TIERS AND
*ruffles make the kind of feminine
evening gown identified with Chanel.
She believed in clothes that were
flirtatious but never flagrantly sexy.*

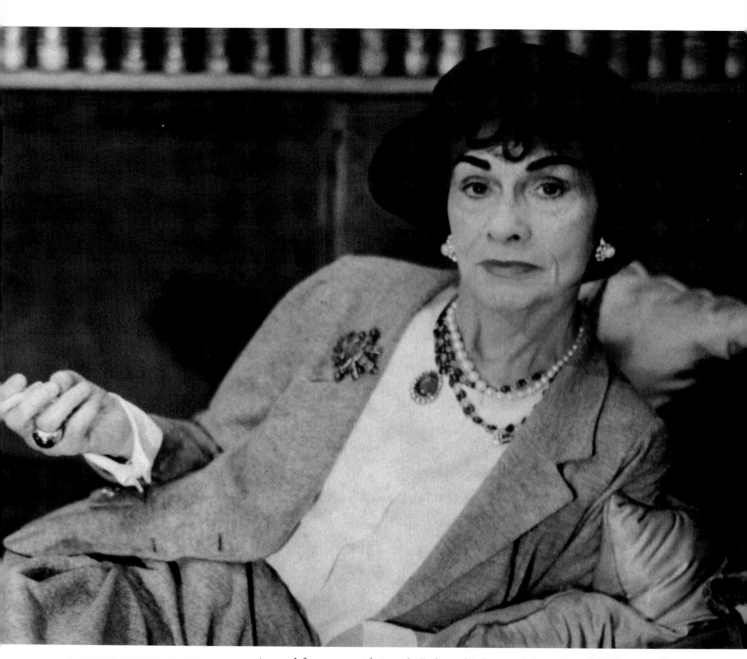

CHANEL WEARS A CLASSIC
jersey suit, similar to ones she did in the 1920s and '30s, with a notched collar and fitted waist, her white cuffs turned back at the wrist. Her earrings, necklaces and jeweled brooch are undoubtedly a mix of the real and the fake. The ring on her right hand was a gift from her lover Boy Capel.

and fortunes with jewels," she told the model Bettina. "I'd have millions if I'd put it all away." But the gems had come from men who were no longer there to embellish her, and she was no longer as eager to seduce new ones with her attentions. Still afraid of solitude, she surrounded herself with females. She had switched her lovers, the fashion world believed, from men to women. Her young and beautiful models, some of them lesbians, all of them molded in her image, became the objects of her affection.

Within a decade of her comeback almost every American woman

would know and want her eponymous suit in soft pastels or rich tweedy plaids, its cardigan jacket edged with contrasting braid and weighted inside with a gold chain, its skirt an easy A-line, its simple blouse matching the lining of the jacket. To Chanel's delight, the suit was copied in every price range at every type of store. While Saks Fifth Avenue featured originals, two hundred copies of one version of the suit were sold in one day at Ohrbach's, a discount store in New York.

The Chanel suit as we know it—collarless jacket, braided trim, slim skirt—is instantly recognizable and universally desirable, as admired in Tokyo or Capetown as it is in Cairo or Rome. Its wearers come from a myriad of places, positions and backgrounds. Actresses and politicians, socialites and sheiks' wives, almost all who wear it are thought to be chic, their bank accounts to be considerable. No matter what currency

CHANEL'S FRIEND AND *former lover Luchino Visconti asked her to design the costumes for Romy Schneider in his movie* Boccaccio '70, *made in 1961.*

ALWAYS FLIRTATIOUS,
Chanel looks adoringly into the eyes
of Alexander Liberman as John
Fairchild (far left) and James Brady
(right) of Women's Wear Daily
look on.

is used, a Chanel suit costs a great deal of money. The richness of the fabrics, the exactness of the cut, the exquisiteness of the details all contribute to the high cost. But the notion of snobbishness is also embedded in the seams. No one was a greater snob than Chanel. For too many years she herself had been sniffed at; when it came time to charge for her creations, she made certain her wealthy customers paid the price. And she understood that the higher the cost, the more her work would be valued.

Yet the real beauty of the suits cannot even be seen. True luxury, she always believed, was hidden from view. "One must feel it," she said; "a woman who feels enveloped in luxury has a special radiance." The intricacies are subtle, the results superb. Pockets may look like decoration, but what better place to hide keys or lipstick, or to poise one's hand? The ubiquitous chain sits innocently enough inside the jacket, seemingly a signature and nothing more, but like everything else, it is there to perform, giving weight to the jacket, holding it down. No matter if

the wearer lifts her arm to hail a cab or raises her shoulders to shrug, the vertical line is straight and smooth, and the high-set sleeve gives her the freedom to move with ease.

Underneath the jacket, the sleeveless blouse allows a woman to stay cool even in an overheated room; yet, with cuffs cleverly attached to the jacket sleeve, and removable to change or clean, the look of the outfit is complete. A ribbon sewn inside the waistband makes sure that the blouse won't slip; the zipper placed close to the hip allows a woman to eat heartily without her stomach showing a bulge. The skirt is cut on the bias, seamed, and slit on the side, or pleated precisely, so that it moves with the wearer whether she walks briskly, runs to a cab or jumps across a puddle. All is practical, all is logical, all is done to make a woman feel good about herself and attractive to a man.

Enduring Allure

FROM A TURN-OF-THE-CENTURY COSTUME that reached above the ankle to a crisp, authoritative ensemble that barely skimmed the knee, Chanel's clothes reflected the forward thinking of their creator. As a designer, she said she was the first to live in her time, but she was more than that; she was the first to live ahead of her time. And like an animal that can feel the tremblings of the ground before an earthquake, her peasant instincts told her of the seismic tremors that were to come. A visionary who witnessed the drastic changes in women's lives during the First World War, she knew that they could never be the same: the frivolous existence of women of the Belle Epoque would disappear forever, replaced in part by ladies dedicated to good works, and in part by women, like herself, devoted to full-time careers.

She envisioned her own life the way she wanted to live it and saw that her liberation would come from herself. Freedom was what she expressed in all that she did. She cropped her hair, suntanned her skin, shortened her skirts, shed her undergarments and made the social pages.

OPPOSITE: IN 1971, TEN *months before she died, Chanel posed for Cecil Beaton at one of her favorite places, the mirrored beige circular stairs in her salon on the Rue Cambon.*

She empowered women through clothes, changing the way they saw themselves by changing the way they moved, the way they felt, the way they dressed. Her clothes made a woman aware of her own body as Chanel was aware of hers. She cut tactile suits for a woman's comfort, fluid jerseys that allowed a woman's body to move without restraint; she designed neat shoulder bags that freed a woman's arms, sling-back shoes that offered easy walking with sex appeal. As for her own sex appeal, she had a way with men. Yet if she flirted unrelentingly, she still managed to concentrate uncompromisingly on her career. The results were romance without binds and a business that knew no bounds.

She saw that the power of men comes not from their genes but from financial independence, and she demanded the same for herself. She saw that men did not own the exclusive right to sexual freedom, and she insisted on the same for herself. She saw that beauty comes from the inside, that covering the body comfortably could free one's spirit, and that function serves as the best inspiration for form.

She created elegant clothes and elegant settings at once comfortable, luxurious and chic, and she entertained an extraordinary range of friends. Her interests varied from the athletic to the intellectual. She was agile all of her life and claimed she had read all of the books in her library. She had a quick mind, a quicker tongue and a wit to amuse the most jaded of men. Her life was a legend of her own making, her past a series of questions that she answered as the mood struck. And when she died in 1971, at the age of eighty-eight, she left the mystery intact.

She lived her life as she wanted it, ran her business as she prescribed it, chose her lovers as she desired them, designed her clothes as she conceived them. She knew that falling trees must be heard and that the best designs in the world would not be sold if the world did not know they existed. She understood the value of publicity, courted the press, controlled her story and condescended to no one. She was always true to herself. Yet she hid the truth, knowing she was creating a legend, and she turned legends upside down to make her own truths. She knew her independence was costly, but she was willing to pay the price of solitude.

She loved with passion and lived every minute to the fullest. From her workers she expected loyalty, from her lovers affection, from her friends attention and from herself discipline and a demand for the best. Whatever she designed, she did with an artist's eye for originality, a

craftsman's hand for workmanship and a tailor's shears for paring down.

Her styles have a sensuality that knows no time, an ease that is still desirable, a minimalism that is still a hallmark of good design. Her look was individual, her outlook universal. She made fashion up-to-the-minute, yet created clothes that were entirely timeless. "Fashion changes but style endures," she said. She was feminine yet never fussy, seductive yet never obscene, understated but never dull. Alluring, enduring, independent and self-assured, Chanel was, and still is, the embodiment of style in the twentieth century.

Photography and Illustration Credits

iv Mademoiselle Chanel. Copyright 1920, D. R. Chanel.

10 Roger-Viollet. Collection Viollet.

10 Roger-Viollet. Harlingue-Viollet.

11 Edward Steichen. After the Grand Prix–Paris, 1911. "The Metropolitan Museum of Art, Alfred Steiglitz Collection, 1933 (33.43.51).

12 Tony Stone Images.

20 Photo courtesy Maxim's de Paris.

21 Photo courtesy Maxim's de Paris.

23 Copyright © 1998 Artists Rights Society (ARS), New York/ADAGP, Paris.

24 Copyright © 1998 Artists Rights Society (ARS), New York/ADAGP, Paris.

25 Hulton Getty/Tony Stone Images.

30 Photo K. Pesavento. Courtesy Special Collections, FIT Library, New York.

32 Photo K. Pesavento. Courtesy Special Collections, FIT Library, New York.

32 Photo K. Pesavento. Courtesy Special Collections, FIT Library, New York.

32 Photo K. Pesavento. Courtesy Special Collections, FIT Library, New York.

32 Photo K. Pesavento. Courtesy Special Collections, FIT Library, New York.

33 Photo K. Pesavento. Courtesy Special Collections, FIT Library, New York.

33 Photo K. Pesavento. Courtesy Special Collections, FIT Library, New York.

33 Photo K. Pesavento. Courtesy Special Collections, FIT Library, New York.

33 Photo K. Pesavento. Courtesy Special Collections, FIT Library, New York.

34 Photo K. Pesavento. Courtesy Special Collections, FIT Library, New York.

34 Photo K. Pesavento. Courtesy Special Collections, FIT Library, New York.

35 Courtesy Sotheby's, New York.

36 Photo K. Pesavento. Courtesy Special Collections, FIT Library, New York.

36 Photo K. Pesavento. Courtesy Special Collections, FIT Library, New York.

36 Photo K. Pesavento. Courtesy Special Collections, FIT Library, New York.

37 Photo K. Pesavento. Courtesy Special Collections, FIT Library, New York.

37 Photo K. Pesavento. Courtesy Special Collections, FIT Library, New York.

38 Roger Viollet. Collection Viollet.

38 Photo K. Pesavento. Courtesy Special Collections, The Fashion Institute of Technology Library (FIT), New York.

39 Photo courtesy of Henri de Beaumont.

40 Hulton Getty/ Tony Stone Images.

41 Courtesy Sotheby's, New York.

40 Courtesy Sotheby's, New York.

43 Roger-Viollet.

44 Roger Schall.

46 UPI/Bettman Newsphotos.

51 Photo K. Pesavento. Courtesy Special Collections, FIT Library, New York.

51 Copyright © 1998 Artists Rights Society (ARS), New York/ADAGP, Paris.

52 Photo K. Pesavento. Courtesy Special Collections, FIT Library, New York.

52 Photo K. Pesavento. Courtesy Special Collections, FIT Library, New York.

52 Photo K. Pesavento. Courtesy Special Collections, FIT Library, New York.

52 Photo K. Pesavento. Courtesy Special Collections, FIT Library, New York.

53 Roger Schall.

54 Courtesy Sotheby's, New York.

55 Photo by Edward Steichen. Courtesy *Vogue*. Copyright 1924 (renewed © 1952, 1980) Condé Nast Publications, Inc.

56 Photo K. Pesavento. Courtesy Special Collections, FIT Library, New York.

58 Photo K. Pesavento. Courtesy Special Collections, FIT Library, New York.

59 Photo K. Pesavento. Courtesy Special Collections, FIT Library, New York.

59 Photo K. Pesavento. Courtesy Special Collections, FIT Library, New York.

60 Roger-Viollet. Harlingue-Viollet.

61 Archive Photos.

62 Copyright © Artists Rights Society (ARS), New York/ADAGP, Paris.

63 Hulton Getty/Tony Stone Images.

64 Roger-Viollet. Martinie-Viollet.

66 Hulton Getty/Tony Stone Images.

67 Hulton Getty/Tony Stone Images.

68 Hulton Getty/Tony Stone Images.

69 Topham. The Image Works.

70 UPI/Corbis-Bettmann.

71 Hulton Getty/Tony Stone Images.

72 Photo by Baron de Meyer. The Metropolitan Museum of Art, Rogers Fund, 1974 (1974.529).

74 Topham. The Image Works.

76 Photo K. Pesavento. Courtesy Special Collections, FIT Library, New York.

76 Photo K. Pesavento. Courtesy Special Collections, FIT Library, New York.

77 Hulton Getty/Tony Stone Images.

79 Photo courtesy Henri de Beaumont.

78 Photo courtesy Henri de Beaumont.

80 Courtesy Vogue. Copyright 1926 (renewed © 1954, 1982) Condé Nast Publications, Inc.

81 Hulton Getty/Tony Stone Images.

82 Photo D. R. Chanel.

85 Hulton Getty/Tony Stone Images.

86 New York Times Company/Archive Photos.

88 Jewelry, collection of Pauline Ginnane-Gasborro.

88 Jewelry, collection of Pauline Ginnane-Gasborro.

89 Jewelry, collection of Pauline Ginnane-Gasborro.

89 Jewelry, collection of Pauline Ginnane-Gasborro.

90 Jewelry, collection of Pauline Ginnane-Gasborro.

90 Jewelry, collection of Pauline Ginnane-Gasborro.

91 Jewelry, collection of Pauline Ginnane-Gasborro.

91 Jewelry, collection of Pauline Ginnane-Gasborro.

92 Jewelry, collection of Pauline Ginnane-Gasborro.

93 Photo F. Kollar, © Ministère de la Culture, France.

94 Museum of Modern Art, Film Stills Archive.

96 Museum of Modern Art, Film Stills Archive.

97 Hulton Getty/Tony Stone Images.

99 Roger Schall.

100 Photo Lipnitzki. Roger Viollet.

101 Hulton Getty/Tony Stone Images.

102 Photo by Moral.

103 Roger Schall.

104 Roger Schall.

105 Roger Schall.

107 Photo F. Kollar, © Ministère de la Culture, France.

110 Photo F. Kollar, © Ministère de la Culture, France.

113 Photo by Horst P. Horst. Courtesy Vogue. Copyright © 1937 (renewed 1965, 1993) Condé Nast Publications, Inc.

114 Photo by Horst P. Horst. Courtesy Vogue. Copyright © 1937 (renewed 1965, 1993) Condé Nast Publications, Inc.

115 Photo by Horst P. Horst. Courtesy Vogue. Copyright © 1937 (renewed 1965, 1993) Condé Nast Publications, Inc.

116 Photo Lipnitzki. Roger-Viollet.

117 Roger Schall.

118 Roger Schall.

119 Roger Schall.

120 Camera Press Ltd./Archive Photos.

121 Photo F. Kollar, © Ministère de la Culture, France.

122 Photo F. Kollar, © Ministère de la Culture, France.

123 Photo by Horst. Courtesy Vogue. Copyright © 1937 (renewed 1954, 1993) Condé Nast Publications, Inc.

124 Roger Schall.

126 Photo by Horst P. Horst. Courtesy Vogue. Copyright © 1939 (renewed 1967, 1995) Condé Nast Publications, Inc.

127 Archive Photos.

128 Photo by Agneta Fischer. Courtesy Vogue. Copyright © 1940 (renewed 1968) Condé Nast Publications, Inc.

131 Photo Lipnitzki. Roger-Viollet.

132 Archive Photos.

133 Photo by Alexander Liberman.

134 Photo by Clarke. Courtesy Vogue. Copyright © Condé Nast Publications, Inc.

136 © P&G Sigal Collection, Brussells.

136 Jewelry, Collection of Pauline Ginnane-Gasborro.

136 © P&G Sigal Collection, Brussells.

137 © P&G Sigal Collection, Brussells.

137 Jewelry, collection of Pauline Ginnane-Gasborro.

137 Jewelry, collection of Pauline Ginnane-Gasborro.

138 Photo by Henry Clarke. Courtesy Vogue. Copyright © 1954 (renewed 1982) Condé Nast Publications, Inc.

139 Photo Helen O'Hagan. The Anna-Maria and Stephen Kellen

Bibliography

AMORY, CLEVELAND, AND BRADLEE, FREDERIC. *Vanity Fair*. New York: Viking, 1960.

ANDERSON, BONNIE S., AND ZINNSER, JUDITH P. *A History of Their Own*. Vol. II. New York: HarperCollins, 1988.

ASSOULINE FOR CHANEL. *Chanel*. Paris: 1995.

BAILEN, CLAUDE. *Chanel Solitaire*. New York: The New York Times Book Co., 1974.

BALLARD, BETTIN. *In My Fashion*. New York: David McKay Company, Inc., 1960.

BARRY, JOSEPH. "Coco Chanel," *Smithsonian*, May 1972.

BEATON, CECIL. *The Glass of Fashion*. Garden City: Doubleday & Company Inc., 1954.

BERG, SCOTT. *Goldwyn*. New York: Alfred A. Knopf, 1989.

BUCKLE, RICHARD. *Self Portrait with Friends: The Secret Diaries of Cecil Beaton*. New York: Times Books, 1979.

CHAMBERLIN, ANNE. "The Fabulous Coco Chanel," *Ladies' Home Journal*, 1963.

CHARLES-ROUX, EDMONDE DE. *Chanel*. London: The Harvill Press, 1976.

CHARLES-ROUX, EDMONDE DE. *Le Temps Chanel*. Paris: Chene-Grasset, 1979.

COLLINS, AMY FINE. "Haute Couture," *Vanity Fair*, June 1994.

CRONIN, VINCENT. *Paris: City of Light 1919–1939*. London: HarperCollins, 1994.

DE LA HAYE, AMY, AND TOBIN, SHELLEY. *Chanel the Couturiere at Work*. Woodstock: The Overlook Press, 1996.

DiGIACOMO, FRANK. "The House that Coco Built," *Elle*, May 1997.

DI PIETRI, STEPHEN, AND LEVENTON, MELISSA. *New Look to Now 1946–1987*. San Francisco: The Fine Arts Museum of San Francisco/Rizzoli International Publications, 1989.

FAUCIGNY-LUCINGE, JEAN LOUIS DE. *Fetes*. Paris: Vendome, 1987.

FAUCIGNY-LUCINGE, JEAN LOUIS DE. *Un Gentilhomme Cosmopolite*. Paris: Perrin, 1990.

FIELD, LESLIE. *Bendor the Golden Duke of Westminster*. London: Weidenfeld and Nicolson, 1983.

FLANNER, JANET. *Paris Was Yesterday*. San Diego: Harcourt Brace Jovanovich, 1988.

GALANTE, PIERRE. *Mademoiselle Chanel*. Chicago: Henry Regnery Company, 1973.

GILOT, FRANCOISE, AND LAKE, CARLTON. *Life with Picasso*. New York: McGraw Hill, Inc. 1964.

GOLD, ARTHUR, AND FITZDALE, ROBERT. *Misia: The Life of Misia Sert*. New York: Alfred A. Knopf, 1979.

GREGORY, ALEXIS. *The Golden Age of Travel 1880–1939*. London: Cassell, 1991.

HAEDRICH, MARCEL. *Coco Chanel*. Boston: Little Brown, 1972.

HALL, CAROLYN. *The Twenties in Vogue*. New York: Harmony Books, 1983.

HARRIS, DALE. "Legends: Chanel and Diaghilev," *Architectural Digest*. September 1989.

HAWES, ELIZABETH. *Fashion Is Spinach*. H. Wolff, 1938.

Hollander, Anne. "The Great Emancipator Chanel," *Connoiseur*, February 1983.

HOUSE OF CHANEL. *Mademoiselle Chanel*. Paris: Societe Anonyme a Directoire et Conseil de Surveilliance, 1991.

HOWELL, GEORGINA. *In Vogue*. New York: Schocken Books, 1976.

JOSEPHY, HELEN, AND MCBRIDE, MARY MARGARET, *Paris Is a Woman's Town*. New York: Coward-McCann, Inc., 1929.

KOCHNO, BORIS. *Diaghilev and the Ballets Russes.* New York: Harper and Row, 1970.

LANOUX, ARMAND. *Paris in the Twenties.* New York: Arts, Inc., 1960.

LAVER, JAMES. *Costumes and Fashion.* New York: Thames and Hudson, 1995.

LINCOLN, W. BRUCE. *The Romanovs.* New York: Doubleday, 1987.

LOELIA, DUCHESS OF WEST-MINSTER. *Grace and Favour.* New York: Reynal & Company, 1961.

MADSEN, ALEX. *Chanel: A Woman of Her Own.* New York, Henry Holt and Company, 1990.

MANN, CAROL. *Paris Between the Wars.* London: Calmann & King Ltd., 1996.

MARIE, GRAND DUCHESS OF RUSSIA. *A Princess in Exile.* New York: Viking Press, 1932.

MARGUERITTE, VICTOR. *The Bachelor Girl* (The Garconne). New York: Alfred A. Knopf, 1923.

MARTIN, RICHARD, AND KODA, HAROLD. *Haute Couture.* New York: The Metropolitan Museum of Art, 1995.

MARX, ARTHUR. *Goldwyn: A Biography of the Man Behind the Myth.* New York: Norton, 1976.

MAURIES, PATRICK. *Jewelry by Chanel.* Boston: Little Brown, 1993.

MICHEL, GEORGES-MICHEL. *La Vie a Deauville.* Paris: Ernest Flammarion, 1930.

MILBANK, CAROLYN REYNOLDS. *New York Fashion.* New York: Harry N. Abrams Inc., 1989.

MORAND, PAUL. *L'Allure de Chanel.* Paris: Hermann, 1977.

MORAND, PAUL. *Lewis and Irene.* Paris: 1922(?).

ORMEND, CATHERINE. *Bukhara Museum Catalogue.* Japan.

PAVLOVNA, MARIE SAI MARIE DE RUSSIE. *Education d'Une Princesse.* Paris: Librairie Stock, 1931.

PAYNE, BLANCHE. *The History of Costume.* New York: Harper-Collins, 1992.

RIVA, MARIA. *Marlene Deitrich.* New York: Alfred A. Knopf, 1993.

SACHS, MAURICE. *The Decade of Illusion.* New York: Alfred A. Knopf, 1933.

SCHOUVALOFF, ALEXANDER. *The Art of Ballets Russes.* New Haven: Yale University Press, 1997.

SERT, MISIA. *Misia par Misia.* Paris: Gallimard, 1952.

SERVADIO, GAIA. *Luchino Visconti.* London: Weidenfeld and Nicolson, 1981.

SHATTUCK, ROGER. *The Banquet Years.* New York: Vintage Books, 1968.

SNOW, CARMEL. *The World of Carmel Snow.* New York: McGraw-Hill Book Company, Inc., 1962.

STEEGMULLER, FRANCIS. *Cocteau.* Boston: Little, Brown and Company, 1969.

STEELE, VALERIE. *Women of Fashion Twentieth Century Designers.* New York: Rizzoli, 1991.

STRAVINSKY, VERA, AND CRAFT, ROBERT. *Stravinsky in Pictures and Documents.* New York: Simon & Schuster, 1978.

THEBAUD, FRANCOISE. *A History of Women.* Cambridge: Harvard University Press, 1996.

VREELAND, DIANA. *D.V.* New York: Alfred A. Knopf, 1984.

WESTMINSTER, LOELIA, DUCHESS OF. *Grace and Favour.* London: Weidenfeld & Nicolson, 1961.

WILCOX, R. TURNER. *The Mode in Hats and Headdress.* New York: Charles Scribner's Sons, 1952.

ZEFFIRELLI, FRANCO. *The Autobiography of Franco Zeffirelli.* New York: Weidenfeld and Nicolson, 1986.

Endnotes

2. "Obviously, they once had a great romantic hour together." Vreeland, Diana, *D.V.* New York: Alfred A. Knopf, 1984, p. 131.

5. ". . . as tough as the peasants who farm there . . ." Author's interview with Fadi Al Khouri, editor, Paris, April 1997.

5. "I am the only crater . . ." Morand, Paul. *L'Allure de Chanel.* Paris: Hermann, 1977, p. 20.

6. "Pride was the key . . ." Ibid., p. 20.

7. "The truth was, they were one of her favorite foods." Ibid., p. 18.

9. ". . . she performed in a popular Moulins cabaret . . ." Charles-Roux, Edmonde, *Le Temps Chanel.* Paris Chene-Grasset, 1973. p. 30.

15. "Decked out in their finery . . ." Shattuck, Roger, *The Banquet Years.* New York: Vintage Books, 1968, p. 11.

15. ". . . brought to life at Royallieu." Ibid., p. 57.

18. "He was more than handsome . . ." Morand, Paul, *L'Allure de Chanel.* Paris: Hermann, 1977, p. 32.

19. "He was her father . . ." Ibid., p. 34.

24. ". . . a shock to the Deauville beauties." Ibid., p. 34.

28. "Not even her exorbitant prices . . ." Steele, Valerie, *Women of Fashion.* New York: Rizzoli, 1991, p. 42.

37. ". . . the rough paneling seemed liked plaster . . ." Morand, Paul, *L'Allure de Chanel.* Paris: Hermann, 1977, p. 99.

37. Chanel had attracted Misia . . ." Gold, Arthur, and Fitzdale, Robert. *Misia: The Life of Misia Sert.* New York: Alfred A. Knopf, 1979, p. 197.

44. "Chanel was drawn to the virile . . ." Morand, Paul, *L'Allure de Chanel.* Paris: Hermann, 1977, p. 121.

49. ". . . Chanel's unstoppable vision." Marie, Grand Duchess of Russia, *A Princess in Exile.* New York: Viking Press, 1932, p. 173.

75. "The famous Coco turned up . . ." Field, Leslie, *Bendor: The Golden Duke of Westminster.* London: Weidenfeld and Nicolson, 1983, p. 201.

75–76. "I've never done anything by halves." Ibid., p. 196.

76. "When two American authors . . ." Josephy, Helen, and McBride, Mary Margaret, *Paris Is a Woman's Town.* New York: Coward-McCann, 1929, p. 12.

83. ". . . a shoulder to lean on . . ." Haedrich, Marcel, *Coco Chanel.* Boston: Little Brown, 1972, p. 124.

84. "As for Misia Sert . . ." Gold, Arthur, and Fitzdale, Robert. *Misia: The Life of Misia Sert.* New York: Alfred A. Knopf, 1979, p. 258.

85. "There is nothing more I can teach you . . ." Schouvaloff, Alexander, *The Art of the Ballets Russes.* New Haven: Yale University Press, 1997, p. 302.

87. "It is disgusting to wander around . . ." Morand, Paul, *L'Allure de Chanel.* Paris: Hermann, 1977, p. 166.

90. "The June season of 1930 . . ." Flanner, Janet, *Paris Was Yesterday.* San Diego: Harcourt Brace Jovanovich, 1988, p. 67.

91. "Chanel did a land office business . . ." Ibid., p. 67.

95. ". . . she was introduced by Linda Porter . . ." Author's interview with Ward Landrigan, president of Verdura, New York, June 1997.

101. "yet, in her peculiar way . . ." Flanner, Janet, *Paris Was Yesterday.* San Diego: Harcourt Brace Jovanovich, 1988, p. 86.

112. "At the Waltz Ball . . ." de Faucigny-Lucinge, Jean Louis, *Un Gentilhomme Cosmopolite.* Paris: Perrin, 1990, p. 114.

119. "Visconti was infatuated with her . . ." Vreeland, Diana. *D.V.* New York: Alfred A. Knopf, 1984, p. 109.

122. ". . . the most beautiful dress . . ." Ibid., p. 96.

128. "What's the worst that can happen . . ." Mann, Carol, *Paris*

Between the Wars. London: Calmann & King Ltd., 1996, p. 193.

129. "Paris went wild . . ." Flanner, Janet, *Paris Was Yesterday*. San Diego: Harcourt Brace Jovanovich, 1988, p. 221.

130. ". . . her fingers were swollen . . ." Haedrich, Marcel, *Coco Chanel*. Boston: Little Brown, 1972, p. 147.

130. "In a moment of exhilaration . . ." Charles-Roux, Edmonde, *Chanel*. London: The Harvill Press, 1989, p. 325.

132. "At my age . . ." Steele, Valerie, *Women of Fashion*. New York: Rizzoli, 1991, p. 48.

133. "They can barely walk." Zeffirelli, Franco, *The Autobiography of Franco Zeffirelli*. New York: Weidenfeld and Nicolson, 1986, p. 100.

138. ". . . the threesome formed a new corporation . . ." Galante, Pierre, *Mademoiselle Chanel*. Chicago: Henry Regnery Company, 1973, p. 181.

140. ". . . Chanel tried to take her revenge." Ibid., p. 182.

140. "I shall never have to work again." Haedrich, Marcel, *Coco Chanel*. Boston: Little Brown, 1972, p. 97.

141. "A small sprightly woman . . ." Author's interview with Mme. Manon, Paris, May 1997.

150. "one of the cruelest experiences . . ." Zeffirelli, Franco, *The Autobiography of Franco Zeffirelli*. New York: Weidenfeld and Nicolson, 1986, p. 128.

154. "When *Vogue*'s Ballard . . ." Ballard, Bettina, *In My Fashion*. New York: David McKay Company, 1960, p. 58.

158. "Nan Robertson . . ." Author's interview with Nan Robertson, New York, March 1998.

158. "She'd keep me until three o'clock . . ." Author's interview with Eleanor Lambert, New York, May 1997.

158–59. "I've made fortunes . . ." Haedrich, Marcel. *Coco Chanel*. Boston: Little Brown, 1972, p. 157.

Index